PAINTING
WORKSHOP

Flowers in
Watercolour

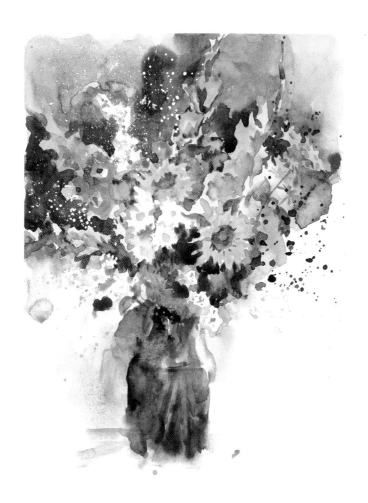

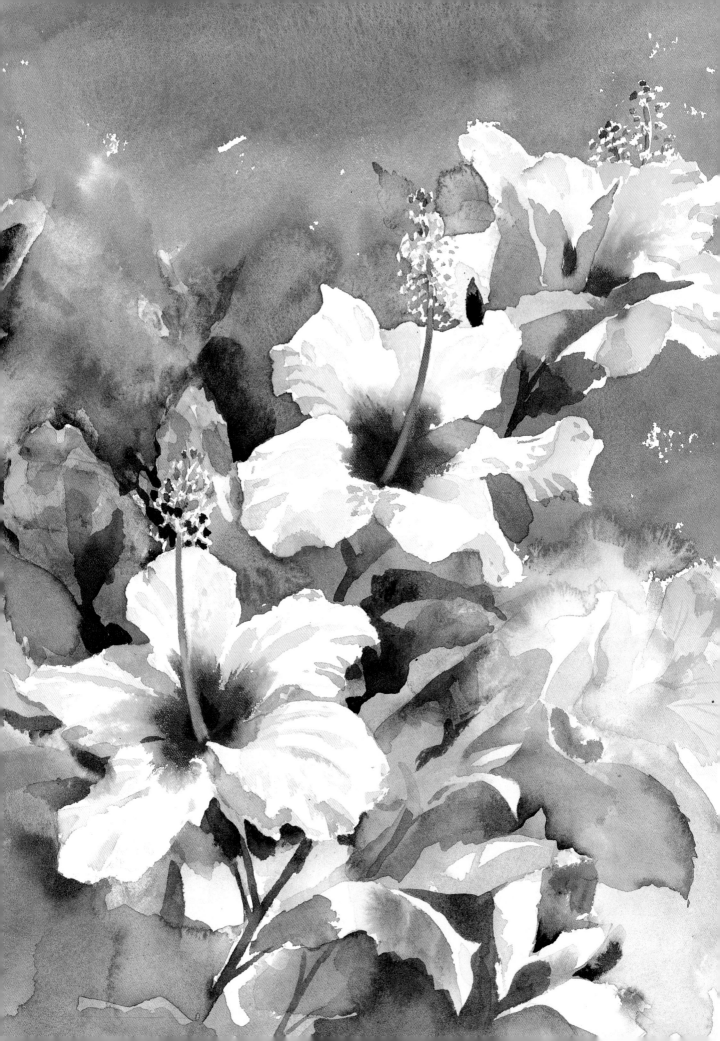

Collins
PAINTING
WORKSHOP

Flowers in
Watercolour

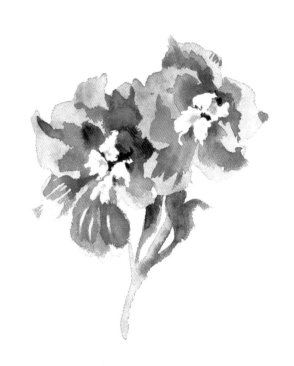

HAZEL SOAN

Dedication
To God who made the flowers

Acknowledgements
To my main editor, Caroline Churton, for being empathetic, sympathetic and enthusiastic. To all the artists for contributing their marvellous pieces of work so promptly and generously, especially Shirley Trevena, John Lidzey and Ann Blockley for their projects and demonstrations. To Cathy Gosling for asking me to write this book, Clare Baggaley for her flare in design, and Geraldine Christy, my text editor. To John, for giving me more and more flowers while I was painting the illustrations, and to Sean for being interested and understanding. To Tony and Gloria Mayes, and all the other friends and acquaintances who have opened up their gardens and homes to me in Cape Town and England.

All paintings are by Hazel Soan unless stated otherwise.

First published in hardback in 1999
by HarperCollins*Publishers*
77-85 Fulham Palace Road
Hammersmith, London W6 8JB

The HarperCollins website address is:
www.**fire**and**water**.com

Collins is a registered trademark of
HarperCollins*Publishers* Ltd

This edition first published in paperback in 2001

08 07 06 05 04 03 02
10 9 8 7 6 5 4 3 2

© Hazel Soan, 1999

Hazel Soan asserts the moral right to be identified as the author of this work.

A catalogue record for this book is available from the British Library

Editor: Geraldine Christy
Layout designer: Tanya Devonshire-Jones
Photographer: Laura Wickenden

Garden Fountain (page 56), *Riverside* (page 86) and *Edge of the Amazon* (page 127) are reproduced by kind permission of Rosenstiel's, London.

A video, *Watercolour Flower Painting Workshop,* to accompany this book is available from Teaching Art Ltd, P. O. Box 50, Newark, Nottinghamshire NG23 5GY (tel. 01949 844050)

ISBN 0 00 712168 7

Set in Cochin, Folio and Stempel Garamond
Colour origination by Colourscan, Singapore
Printed and bound by Printing Express Ltd, Hong Kong

Page 1: Hazel Soan, watercolour sketch
Page 2: Hazel Soan, *Facing the Sun* (detail)

Co

ntents

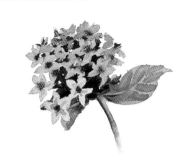

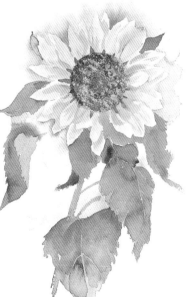

About this book

The aim of this book is to encourage you to learn by doing, just as you would in a practical painting workshop led by a tutor. Along with instructional teaching and general guidelines in the text, you will find practical exercises and projects for you to do, designed to help you to develop as an artist. If you carry out all of these before moving on, they will effectively help you to understand the teaching.

As you practise and become more visually receptive and perceptive about the world around you, your own ideas, and personal style, will begin to emerge.

Exercises and Practical Tips

Throughout the book you'll come across simple exercises and practical tips. The exercises are quite short and should not take too long to do; their aim is to get you painting and thinking for yourself. The tips highlight some useful hints about working methods and provide a few solutions to everyday painting problems.

exercise

practical tip

Demonstrations

Because you can learn a great deal by watching professionals at work, several demonstrations by the author and other artists are included in the book. These show how a painting is developed from the initial drawing to the finished work, and you are taken step-by-step through each stage so that you will understand what techniques are used and how particular effects are created. Details from the paintings are included to highlight specific areas of interest.

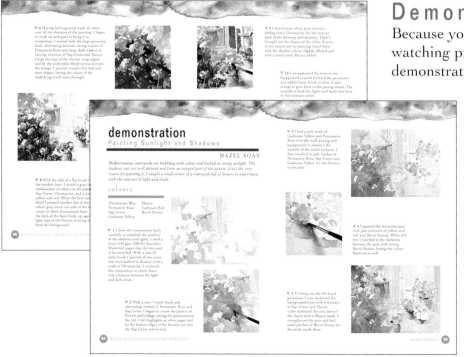

Projects

The projects, of varying degrees of difficulty, concentrate on more specific aspects of painting, with a view to sparking off ideas which you can then interpret in your own way.

Try to take your time with the projects and be prepared to reread relevant sections of the text as often as you need to enable you to tackle them successfully. After all, there are no short cuts to learning to paint well!

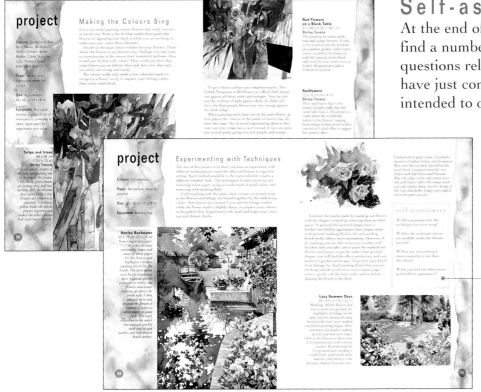

Self-assessment

At the end of each project, you'll find a number of self-assessment questions relating to the work you have just completed; these are intended to draw your attention to particular aspects of your painting, in the same way that a professional tutor might help you to assess your work in a practical workshop.

self-assessment

Ideas and Inspiration

The paintings in the book, by the author and several other well-known contemporary artists, cover a wide range within the subject. Some of these paintings are meant to complement and clarify points explained in the text, but others are included to show how style and technique vary from one artist to another, emphasizing the importance of being original in your creative work. They can help you to extend your horizons – and fire your enthusiasm. They are there for you to enjoy!

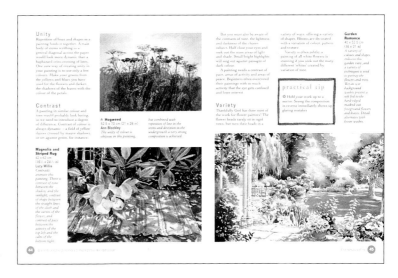

the *attraction* of *flowers*

Flowers are **outrageous**. They are wild and unrestrained, **shocking** in their choice of colours, **dazzling** in their presentation, matchless in their **beauty**.

Flowers are **daring**. Is there any other subject matter to compete in **colour**, shape, abstraction, or **boldness**? They have attracted the enthusiasm of painters such as Claude Monet, Edgar Degas, Vincent Van Gogh and Andy Warhol. Flowers are always modern, **vibrant**, avant garde. They lift **heart**, soul, mind and senses.

Flowers have character. They can be **passionate**, proud and **extrovert**, or shy and reticent. Often they are **romantic**, and occasionally they are funny, but they are always **cheerful** and convey a **joie de vivre**. No wonder so many artists **paint flowers**!

chapter one

ENDLESS INSPIRATION

Rich in **colour** and **variety**, flowers provide the perfect vehicle for exploring watercolour. With its **translucent** washes and shimmering qualities, watercolour is the ideal medium for painting the radiance and expression of flowers.

This book aims to **inspire** you to create evocative flower paintings. The techniques you will need are explained visually, and projects and demonstrations put them into practice.

All the Colours of the Rainbow
75 x 55 cm (30 x 22 in)

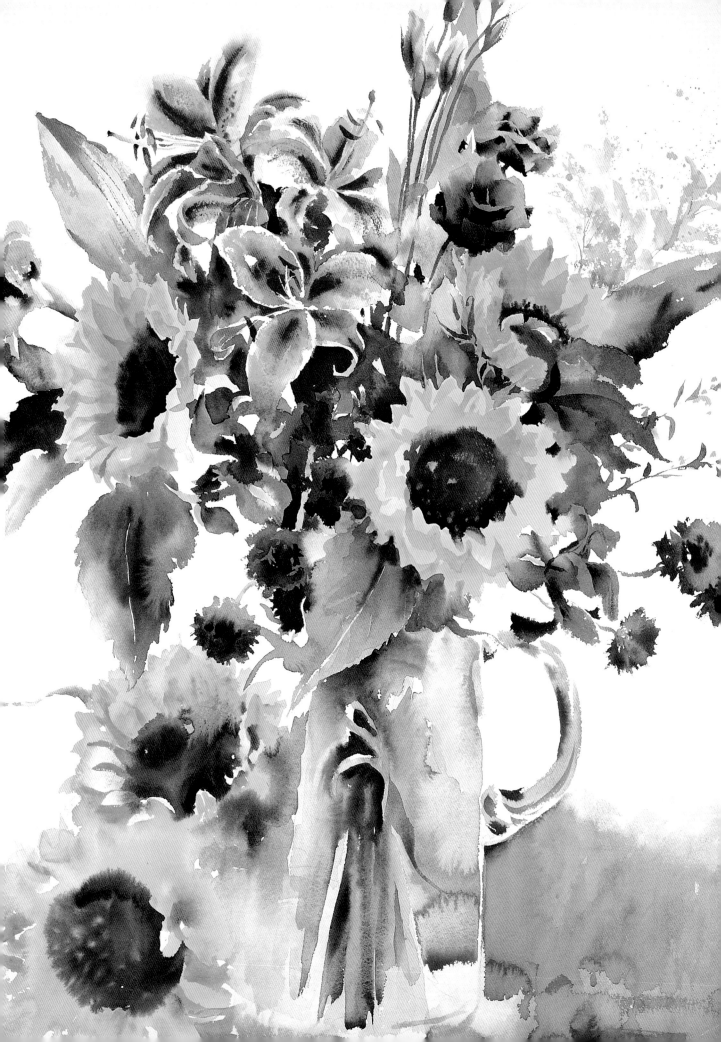

Flowers and watercolour

Flowers are ideal subjects for learning to paint in watercolour. Not only do they give you opportunities to try out every colour and technique, but better still, inaccuracies of drawing are less crucial than with a figure study or still life. You can go straight into painting and concentrate on what attracts your attention, takes your fancy, and demands your time.

This means you are free to experiment. You can mix colours you would not normally use in the landscape and you can convey and create expression in your paintings without worrying about exact reproduction.

Swiftly rendered washes and clear colours placed with deft brush strokes make watercolour the perfect medium for those whose busy lives leave them little time to paint, but love to have a go.

The perfect match

The radiance of watercolour painting relies on light being reflected from white paper through transparent layers of colour, much the same as sunlight shining through petals. The transparent layers and variations of tone within a watercolour wash perfectly portray the interplay of overlapping petals. A touch of deep dark pigment plunged into a paler hue needs no helping hand to suggest the hidden depths within a bloom.

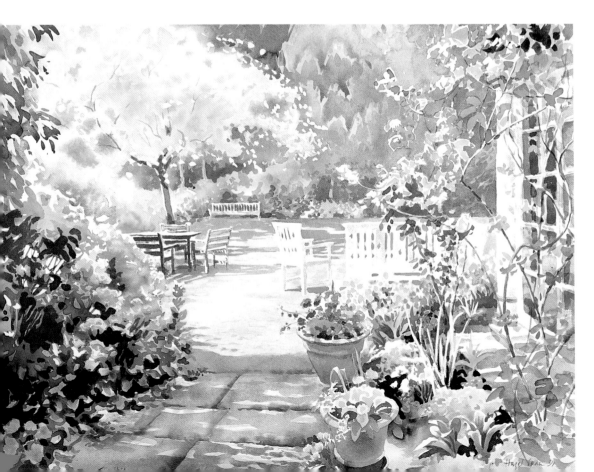

Chelsea Arts Club Garden
55 x 75 cm (22 x 30 in)
Watercolour likes a measure of freedom, and lovely effects occur as it dries. Place it, and resist the temptation to fiddle; the less you interfere the more beautiful are the qualities that it is likely to reveal. Gardens are similar; they benefit from both control and freedom.

Developing your style

As with your handwriting, one of the most unique qualities you possess is your style of painting. You may well be attracted to another artist's technique and there is no harm in emulating it. Copying is a marvellous way to learn – but you may struggle and struggle, and find in the end that someone else's way does not come naturally to you, leaving you dissatisfied.

This book aims to help harness your own vision and your thrill with flowers, so that you can exploit watercolour to your own advantage. You may prefer to render carefully the exacting beauty of a single bloom, and to explore its every vein and fold. Or you may wish to cast colour across the page with inspired abandon. Or you may just love the perfect excuse to sit out under an open sky, with a slight breeze brushing your cheek, to enjoy painting at your leisure the most colourful subject on earth. In so doing you will develop a style of your own.

Enjoying your painting

Watercolour is such an attractive medium that even while you are learning, you can derive sheer pleasure from the mouthwatering colours, the soft sable brushes and the attractive heavy papers. Even better, this enjoyment of the medium will translate into your paintings.

With such a glorious subject as flowers to paint, no matter how frustrated you may become with

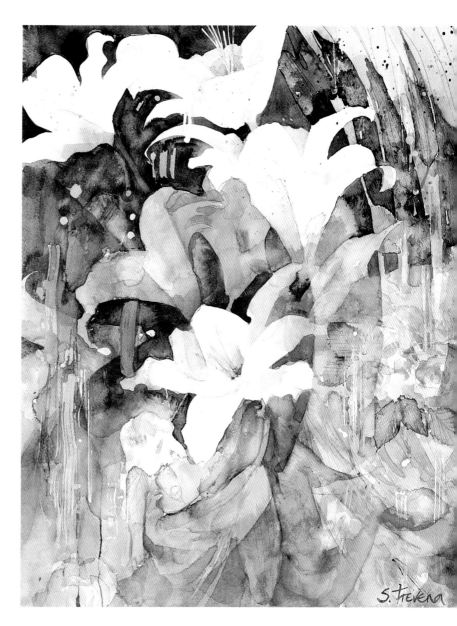

White Lilies and Pink Roses
50 x 40 cm (20 x 16 in)
Shirley Trevena
The organic shapes and exuberant nature of flowers present lots of opportunities to play with interesting compositions.

your actual painting, just being in their presence will uplift you.

You are embarking upon an exciting journey. Monet became absorbed with waterlilies, and Van Gogh with sunflowers. Artists of all generations have found flowers irresistible. Now it is your turn to have a go.

Materials and Equipment

One **advantage** of painting with **watercolour** is that you need very little equipment. I love to go out with just a **small bag** containing a **palette** of watercolours, one or two **brushes**, a **sketchpad**, a bottle of **water** with two small containers, and a roll of **kitchen paper**. I never take an easel and rarely use a stool, preferring instead to **find a perch** wherever I choose to **paint**. If it is damp I sit on a plastic bag. This may not suit everybody, but I have found that the **more** you have to prepare to **go out** painting the less likely you are to go.

A PORTABLE STUDIO

If you are **working indoors** and have space to keep your materials laid out, you can use a lot more **paints** and **brushes**, but most beginners do not have their own **studio** and the **kitchen table** may be your only work surface.

I suggest you have an equipment bag as a '**portable studio**'. If you cannot find a suitable custom-made one, a large camera bag works well – the size of your favoured **sketchbook** will determine the most **practical** dimensions. Keep the water bottle topped up, and then, whenever you want to **rush out** and paint those **blooms** before the sun goes down, or that vase of flowers in the bedroom, just grab the bag and **you are ready** to start.

Flowers in the Studio
24 x 20 cm (9½ x 8 in)
John Lidzey

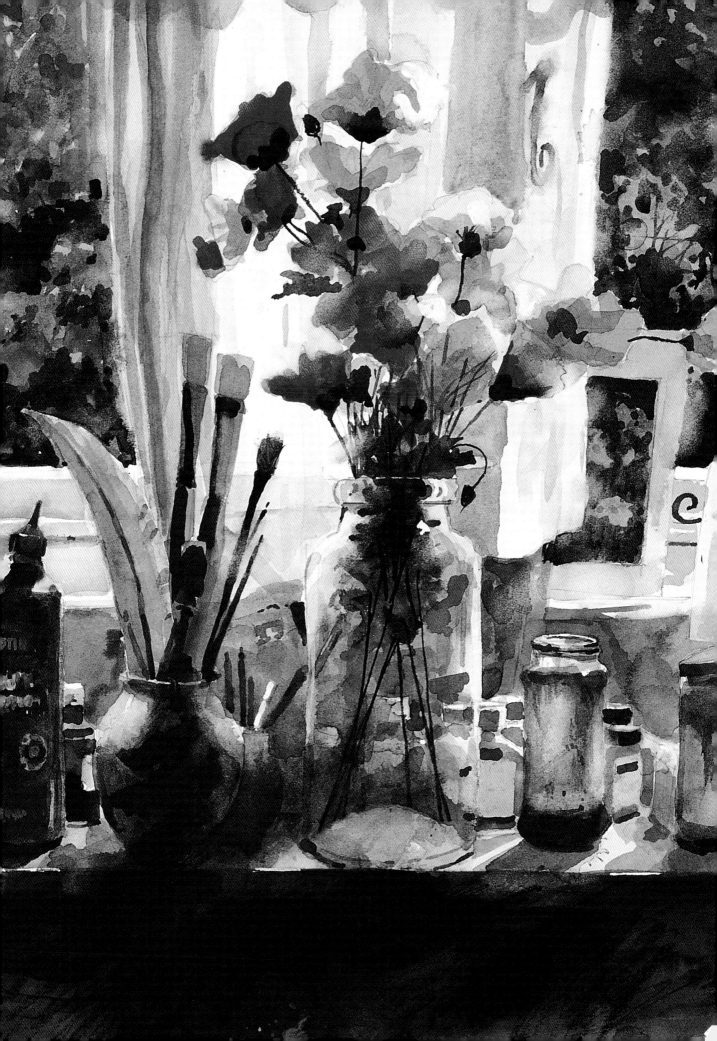

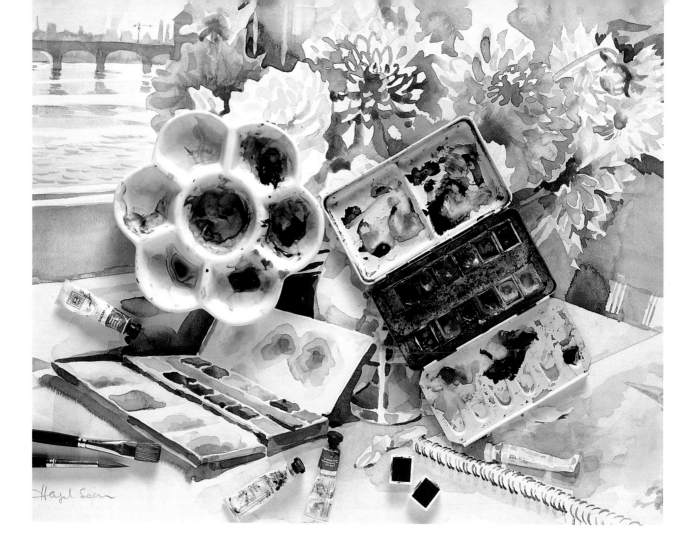

Choosing materials

Beginners often make the mistake of buying cheap materials and then wonder why they cannot achieve the wonderful effects they see in the art books they study. Good art materials are expensive, but you need surprisingly few to start and the difference in quality is immeasurable.

Paints

Watercolour paints are available in tubes or ready pressed into pans. Most artists use a mixture of pans and tubes. To begin with I suggest either a small folding metal palette with pans of colour, or individual tubes (see suggested colours opposite) and a separate metal or china palette. If you can afford them, choose artists' quality paints rather than student quality. The pigments are superior.

exercise

❀ Choose five different-coloured flowers. As well as single-coloured flowers, select some with multicoloured petals. By mixing one, two or three colours together with a little water, try to match the colours of the blooms as closely as you can.

Choosing art materials is great fun. Enjoy the choice, and be prepared to experiment.

These are the colours that I recommend you use to begin with.

Suggested colours

All the colours you will ever paint are made up from just three – red, yellow and blue.

As you mix these together so you can create greens (blue and yellow); oranges (red and yellow); violets (blue and red); browns, greys and blacks (red, yellow and blue).

You could paint with just three colours. However, painting flowers gives you the glorious excuse to use a lot of variations of red, pink, mauve, yellow and green, and watercolours can be bought in a wonderful array of colours, so let us enjoy them.

Here is the selection of colours I used to paint most of the flower pictures in this book. It is not a definitive choice and may vary considerably from the selection in a ready-made palette. It includes colours that could almost be mixed from two others, but are so intense and vivid straight from the tube that it seems a shame not to use them. In choosing your colours it is wise to pick a warm and cool version of each colour. Chapter 7 explains how to use the 'temperature' of colour.

Use as few ready-mixed colours as possible in any one painting; rather mix two or three colours together to make others. As you dilute your colours with water you will discover myriad more shades. Add to your list a tube of white gouache, an opaque white which is ideal for small highlights and can be mixed with watercolour to increase opacity.

Cadmium Red Deep – warm red

Permanent Rose – cool red

Alizarin Crimson – cool red

Cadmium Yellow Deep – warm yellow

Lemon Yellow – cool yellow

Aureolin – cool yellow

Yellow Ochre – warm yellow

Sap Green – warm green

Viridian – cool green

Prussian Blue – cool blue

Cobalt Blue – warm blue

Ultramarine Blue – warm blue

Mauve – warm 'blue'

Indigo – cool blue

Sepia

Brushes

The amount of pigment a brush can hold and the brush strokes it lays are the essence of watercolour painting. You cannot make effective brushmarks with cheap brushes. There is a noticeable difference between synthetic and sable brushes and it is certainly worth investing in one decent brush. It will retain its point longer and enable you to make both fine detail strokes and broader washes.

If you intend working small, say up to 25 x 35 cm (10 x 14 in), you only need one brush. Choose one with a good tapering point, preferably sable, a size 5 or 7 depending on the make. You can test brushes in water in the art shop. Be fussy. If I am not happy with a brush I find it very difficult to paint well.

You can add other brushes to your collection, either for making different shaped marks or because you want to lay large washes or finer detail. A cheap thin brush for applying masking fluid might also be a sensible addition.

Brushes are very versatile. From left to right:

1 Size 00 sable for fine detail.

2 Size 3 for detail and small washes.

3 The rigger for painting fine trailing lines.

4 Sizes 5-7. The perfect all-round brushes for washes and detail.

5 Size 12 for larger washes and details.

6 12mm (½ in) flat brush for washes and edge lines.

7 25mm (1 in) flat brush for washes and stems.

Paper

Watercolour lies and settles differently on different papers.

Surface

There are three choices of paper surface:

HP, which stands for hot-pressed. This is a smooth paper. The paint floats more on this surface, making it easier to coax the colours into blots, backruns and crisp edges.
NOT, meaning not smooth and not rough. For a beginner this is the best paper to start with. Washes blend evenly and easily, the paint settles gently, and you will soon learn to work wet-in-wet and wet-on-dry with predictable results.
ROUGH is a rough-textured surface available with different texture (or 'tooth'). Wonderful effects are created as the paint skims the surface or settles in the grain.

Thickness

The thickness of the paper also affects the finish of the watercolour. Buckling (or cockling) occurs if you use thin papers. though you can stretch paper to prevent this.
The thickness of paper is described by weight:
190gsm/90lb is a thin paper good for painting flower studies without background washes.
300gsm/140lb is a medium-weight paper popular in sketchbooks and thick enough for most purposes. This is the paper I recommend for beginners.
600gsm/300lb is heavy and thick. If you want to work very wet you will enjoy this paper.

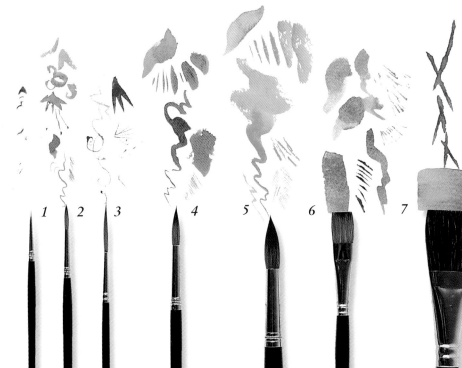

1 2 3 4 5 6 7

Stretching paper

The proper way to stretch paper is to immerse it in water for about 30 seconds, then lay it on a board and stick it down all round with wetted gumstrip, making sure the tape adheres firmly to both the paper and the board. Wait until the paper is absolutely dry, sometimes overnight, before painting on it.

However, if you cannot wait to get started, sticking masking tape firmly round a sheet of dry paper can also do the job, but make sure you do not let water run under the tape or work too wet.

Easels and drawing boards

If you are using sheets of paper rather than sketchbooks and blocks you will require a board. You can make your own from a piece of 6mm ($^1/_4$ in) plywood or hardboard cut to any size. I am not fond of using an easel for watercolour painting outside, but it does give you a better view of the picture surface and enable you to stand back.

Pencils and erasers

Pencils come in degrees of hardness and softness, HB being in the middle of the range. A 2B pencil is ideal for drawing under watercolour. It is also easy to erase. Stiff erasers will scuff the paper, so opt instead for a gentle putty rubber. Once watercolour is painted over a pencil mark you cannot remove it, but letting your pencil marks show through can add life to a painting.

Enjoyable extras

Add these items to your equipment bag if you wish: masking fluid; white wax candle; natural sponge; scalpel; waterproof ink; and an old toothbrush.

Paper is available loose or in sketchbooks. If you work fairly wet try a sketchblock, in which the paper is stuck down at the edges. Experiment with different surfaces and tinted papers.

Watercolour techniques

Watercolour's greatest asset is its **transparency**. Learning to manipulate that quality to make successful paintings is called **technique**. Generally watercolour paint is diluted with **water** and applied with a brush to paper. You can **create colours** by mixing in the palette, by **overlaying** transparent washes, or by actually **blending** them on the paper. The brush is designed to create meaningful strokes as you lay the paint down, whether the pigment is **wet** or **dry**, thick or thin. You can also employ **other tools** for making marks, such as sponges, masking fluid and wax.

CREATING THE MAGIC

The success of a painting is not dependent on technique alone. There are many other aspects that all play an important role in the creative process. Good **composition**, drawing, and the use of **colour** and tone combine to make a painting 'work'. The **wonderful mystery** that makes a painting 'sing' to one person and another to someone else, is more often to do with the spirit in which it is painted than the **mastery** of technique. But if you are **confident** in the handling of paint and know the means by which you can lay it down, you are more likely to be able to impart that **magical essence** that will make not only the process but also the finished work worthwhile.

Florist's Window
50 x 40 cm (20 x 16 in)
Shirley Trevena

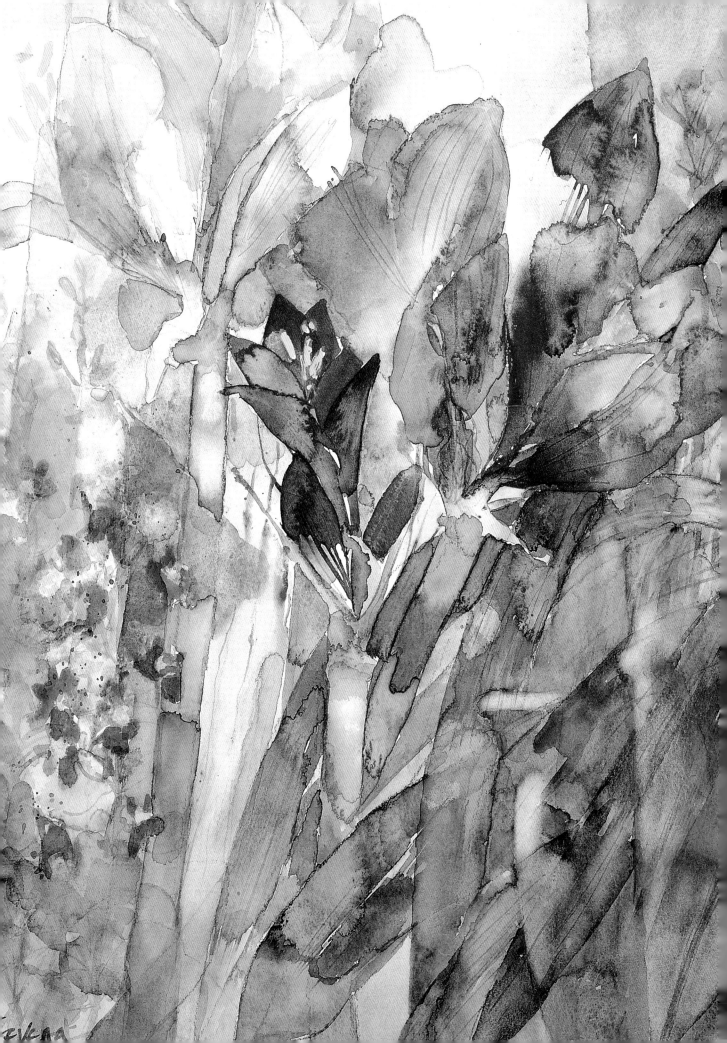

What is a wash?

Every area of paint applied to paper is a wash of sorts. Except for small details and lines, or paint brushed on very dry, most of the marks you will make with wet paint and a brush are washes, small or large.

Background washes fall into three categories. A flat wash is smooth, evenly laid paint of one colour. A graduated wash changes tone; that is, it gets lighter or darker as it progresses across the page (you might use this for a sky gradually lightening towards the horizon, for instance). But probably the most useful large wash for a flower painter is a variegated wash. This occurs when you blend two or more colours together wet-in-wet, either in bands or in blotches. This wash will give you a wide variety of backgrounds, suggesting undergrowth, distant flowers, anything you wish!

All washes can be painted onto dry paper, but to aid blending in a large wash dampen the paper with pure water first. Stretch the paper if it is thin.

▶ *The blue background to the flowers shows part of a flat wash. Lay the paint in broad even strokes, with a large brush slightly overlapping each stroke. Never go back over the wet paint, even if it looks uneven; let it dry in peace!*

▼ *A variegated wash is ideal for hinting at foliage behind flowers. Drop the dark colours into the wet green wash close to the petals to suggest depth.*

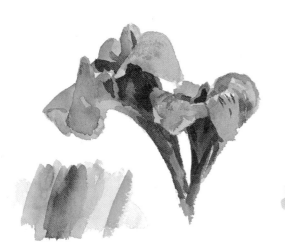

Two main techniques are employed by the watercolourist: wet-in-wet, and wet-on-dry. On the left the canna flower is painted with wet paint over dried washes, and built up in overlapping translucent colours. On the right the flower is painted wet-in-wet by adding rich wet colour to damp or drying washes, creating a soft appearance.

Touch colour to the edges of the flower as well as the centre while the wash is wet. Let it spread unhindered. Already you will have hinted at the form of the flower by letting the watercolour do the work for you.

Wet-in-wet

If you lay a wet wash of colour on the paper and add another wash to the first while it is still wet you are working wet-in-wet. The colour blends on the paper creating lovely, soft-edged effects. Sometimes more of the same colour is added or a different colour is used. Gradual variations in colour, tone and texture are created. Even when the paint runs back and forms unplanned backruns, the effects, especially in flower painting, are beautiful.

▶ *Wet-in-wet is marvellous for creating dark centres. Paint the shape of a bloom with a wet wash; here Indian Yellow is used to suggest a sunflower. Before this dries mix a mauve for the middle, and using less water, brush, dab or drop this colour gently into the centre of the bloom and leave it to spread untouched.*

▶ *The petals and the stem of this gladioli were painted wet-in-wet. To prevent the pink edges running into the petals behind, the pale yellow was allowed to dry and then re-wetted a petal at a time with a little pure water. Strong Permanent Rose was then brushed in from the edge of the petal.*

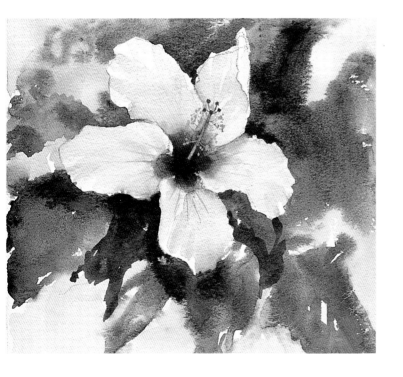

Wet-in-wet washes also make wonderful backgrounds for flower paintings. The soft, out-of-focus leaves just hint at what might lay behind.

Wet-on-dry

You have total control when working wet-on-dry. The wash must be allowed to dry completely before another one is laid on top. The colours do not run into each other, but are built up in transparent layers one upon the other, or laid beside each other and kept separate.

The glow of the colour underneath comes through the top layer, making yet another colour. By never totally covering the underlying washes a rich variety of colour is created throughout the painting.

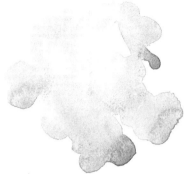

▲ *The shape of the flower group is painted and allowed to dry. Another wash of the same colour is then painted on top to describe the petals of the individual flowers. See how quickly the painting takes shape.*

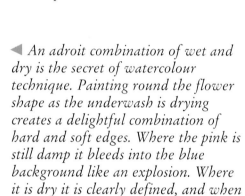

◄ *An adroit combination of wet and dry is the secret of watercolour technique. Painting round the flower shape as the underwash is drying creates a delightful combination of hard and soft edges. Where the pink is still damp it bleeds into the blue background like an explosion. Where it is dry it is clearly defined, and when almost dry, slightly fuzzy-edged.*

Dry-brush

Watercolour paint does not need to be wet to create great marks. Often in painting flowers you will find you need a feathery mark, or a broken wash. If you use your paint almost dry from the pan or tube, or from colour dried on the palette, you can achieve these effects. Before laying your brush on the paper tap or blot any excess moisture from the hairs and then drag the brush across the surface of the paper.

▶ *Dry-brush is ideal for the fine feathery stamens of this bottlebrush. To fan the brush stroke load the brush with dry paint and splay the hairs apart with your fingers.*

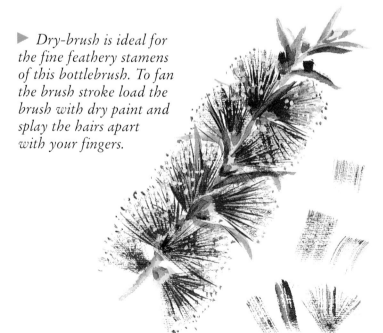

Highlights

Watercolour is brought alive by the contrast between light and dark colours. The lightest areas, where the sun or other light source bleaches out the colour, are called highlights. The following techniques will enable you to create them. They will also help you to lighten a detail or area on a wash already laid.

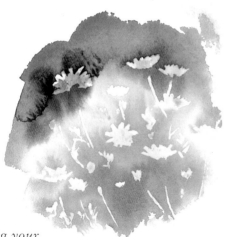

Get into the habit of noting the highlights before you start to paint and then leave them as white paper for the duration of the painting. If you have left too much white paper you can always tint it with colour at the end.

Reserving white paper

The lightest highlights in watercolour will be the untouched white paper. As a petal or leaf twists and turns so the light catches a corner or a raised edge. Sometimes in bright sunlight this patch of light is dazzling. Leaving the paper to represent these brightest lights is one of the secrets of successful watercolour painting. You can never bring them back with white paint, because the paint is opaque. Likewise, as you paint backgrounds, do not be afraid to leave small patches of paper unpainted; it is not necessary to fill these areas in like wallpaper! Flecks of white add shimmer and sparkle to the painting.

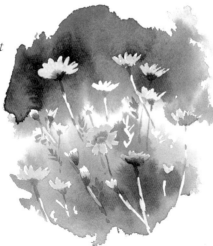

By covering your flower heads with masking fluid you can confidently paint the background knowing that the flowers themselves will remain pristine. When the background is dry, rub the masking off with your finger or a putty rubber, and paint the flowers.

Masking

Masking fluid is a latex solution which you paint onto areas of the paper to protect them from any wash painted on top. It will ruin a good brush, so use an old one and rinse it immediately after with warm soapy water. When the paint is dry the masking can be removed, revealing the untouched paper.

Lifting out

Softer highlights can be achieved by literally lifting off the paint with a brush or rag. Lifting out is ideal for highlighting the curvature of a petal or leaf, where it faces the light, or for lifting out stamens or pale centres from a darker wash. If the paint is still wet gently use a dry brush, tissue or cotton bud to absorb the unwanted paint. If the paint is already dry you will need to use a damp brush, sponge, or tissue with a gentle rubbing motion to loosen and lift the colour from the surface of the painting.

Wax resist

Anything that repels water will also act to reserve white paper or colour from succeeding washes. Use a plain white candle or a white oil pastel to draw highlights onto your petals, or into the background. Successive waxing on top of washes can be particularly effective for building up an exciting background. Be warned, however; once you have waxed an area it cannot be removed, so be discriminating in your application.

▲ *To 'paint' the stamen lift the colour out with the tip of a damp brush. You may need to run it several times over the length of the stamen. Blot with a dry cloth. A soft swipe with a damp sponge lifts the area for the anthers. A stain of colour is usually left on the paper.*

After laying a pale yellow wash, wax is applied with a candle to protect the pale areas of the variegated leaf from the subsequent green washes. The broken nature of the paint settling on the wax creates wonderful textures.

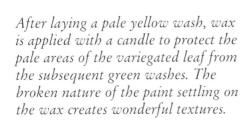

Scratching out and scraping off

Tiny flecks of light and fine, energetic, lines can be scratched out with the sharp blade of a scalpel. The deeper you scratch the whiter the line, as you scratch into the actual paper itself. Ideally this should be done at the end of the painting, when the paper is thoroughly dry, to prevent tearing. A thicker paper is also recommended.

White paint

All the preceding techniques for creating highlights in the painting use the lightness of the white paper. There are times, however, when you might prefer to use white paint for this purpose. The light can never be as crisp or bright as the untouched white paper, but that is not always wanted or necessary. To touch in the anthers on the end of stamens, or draw in the veins of leaves, white paint is ideal. For a thick opaque white I recommend white gouache. You will need to use it neat from the tube for bright whites, or gradually dilute it for pale white lines. It dries much less white than it looks when wet, so be prepared.

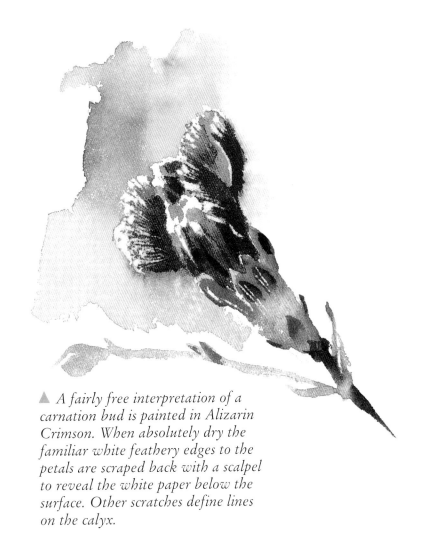

▲ *A fairly free interpretation of a carnation bud is painted in Alizarin Crimson. When absolutely dry the familiar white feathery edges to the petals are scraped back with a scalpel to reveal the white paper below the surface. Other scratches define lines on the calyx.*

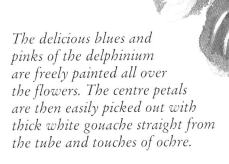

The delicious blues and pinks of the delphinium are freely painted all over the flowers. The centre petals are then easily picked out with thick white gouache straight from the tube and touches of ochre.

Sponging

There are occasions when you need a speckly appearance or a multitude of tiny dots, for the centre of a flower, a spray of tiny blooms, or a hint of background foliage. A natural sponge dipped in a creamy mixture of paint and then applied to the paper makes a random mottled pattern that is hard to match with the brush. If the area is small and defined, cut a stencil from paper to protect the rest of the flower.

Spatter and flicking

Spattering or flicking paint onto the picture from the end of a loaded brush can create exciting, spontaneous-looking textures. Make sure there is plenty of pigment in your solution, otherwise the blots will dry too light. Take care when applying paint in this way, and cover areas that you wish to protect.

For a finer spatter, load creamy paint onto an old toothbrush, and pull your finger back across the bristles to release a fine spray of colour onto the painting. Build this up with many colours to create a soft grainy texture for a vase or background.

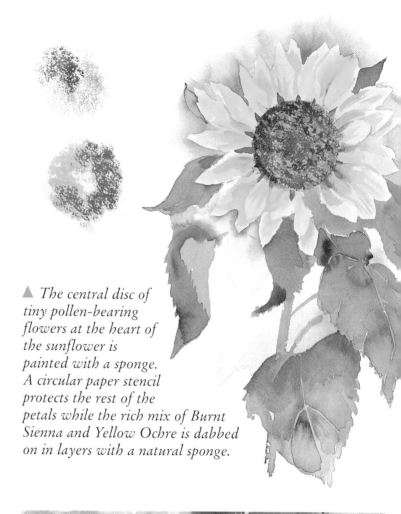

▲ *The central disc of tiny pollen-bearing flowers at the heart of the sunflower is painted with a sponge. A circular paper stencil protects the rest of the petals while the rich mix of Burnt Sienna and Yellow Ochre is dabbed on in layers with a natural sponge.*

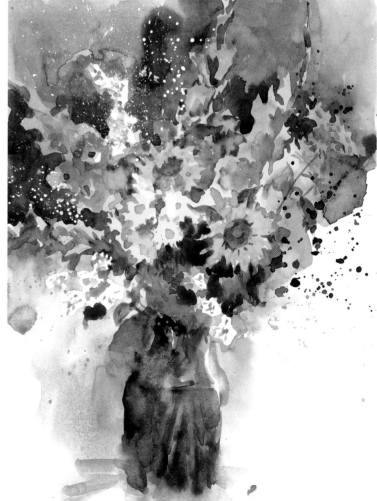

White, purple and yellow paint has been flicked across the painting to enliven the bunch of flowers. The loaded brush was positioned at the point where the flowers enter the vase so that the spattered blobs followed the lines of the outgoing flowers.

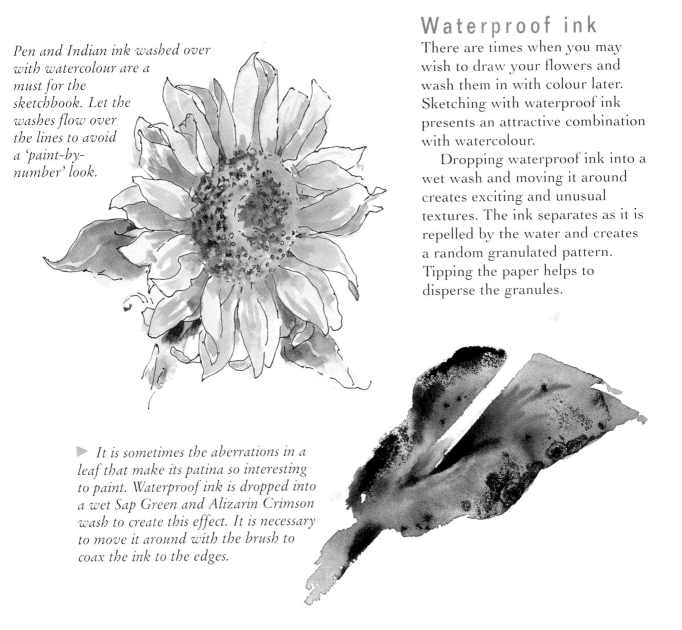

Pen and Indian ink washed over with watercolour are a must for the sketchbook. Let the washes flow over the lines to avoid a 'paint-by-number' look.

Waterproof ink

There are times when you may wish to draw your flowers and wash them in with colour later. Sketching with waterproof ink presents an attractive combination with watercolour.

Dropping waterproof ink into a wet wash and moving it around creates exciting and unusual textures. The ink separates as it is repelled by the water and creates a random granulated pattern. Tipping the paper helps to disperse the granules.

▶ *It is sometimes the aberrations in a leaf that make its patina so interesting to paint. Waterproof ink is dropped into a wet Sap Green and Alizarin Crimson wash to create this effect. It is necessary to move it around with the brush to coax the ink to the edges.*

Corrections

Many people think you cannot correct mistakes in watercolour and it is therefore a difficult medium to learn. While it may be true that continually reworking areas kills off the freshness of a painting, it is actually possible to remove disaster areas and to repaint them. From the many techniques illustrated you will have realized it is quite possible to add or take away from a painting in a multitude of ways.

Most watercolourists use well-sized papers that do not totally absorb the paint, so colours can be lifted off when wet, even on a large scale, with a kitchen towel or cotton wool and plenty of water if necessary. If the paint is dry use a damp natural sponge and a gentle rubbing motion. Try not to disturb the surface of the paper. Wait until the paper is absolutely dry before repainting. Even if a stain is left you will find it may not be visible when you have painted on top.

looking at *flowers*

You do not need to be a **botanist** to paint convincing watercolours of **flowers**. Sometimes it is the very **quirkiness** of an awkward drawing that makes a **painting appealing**, such as we enjoy in a child's picture. But often the opposite occurs and a piece of impossible drawing in an otherwise **good watercolour** will irritate instead of **excite** the viewer. Common problems for beginners occur in depicting where the **stem** meets the **flower**. The stem continues up into the **stamens** or pistil and inexperienced painters tend to forget that the line must carry through, otherwise the flower will look disjointed. Others have difficulty with the **overall shape** of a flower head, especially if it is made up of many parts.

chapter fou

RECOGNIZING THE SHAPE

Most flowers, however complicated, **happily** fall into **basic shapes**. If you become **familiar** with these shapes and apply them to the blooms you are painting **the flowers** will take on the correct **three-dimensional** form and become plausible in the painting.

This chapter **divides flowers** into eight general **shapes**. When confronted with your subject decide which group it comes under and draw the underlying **form** first. This will quickly **improve** your drawing and **enhance** your paintings.

Resurrection
73 x 50 cm (29 x 20 in)

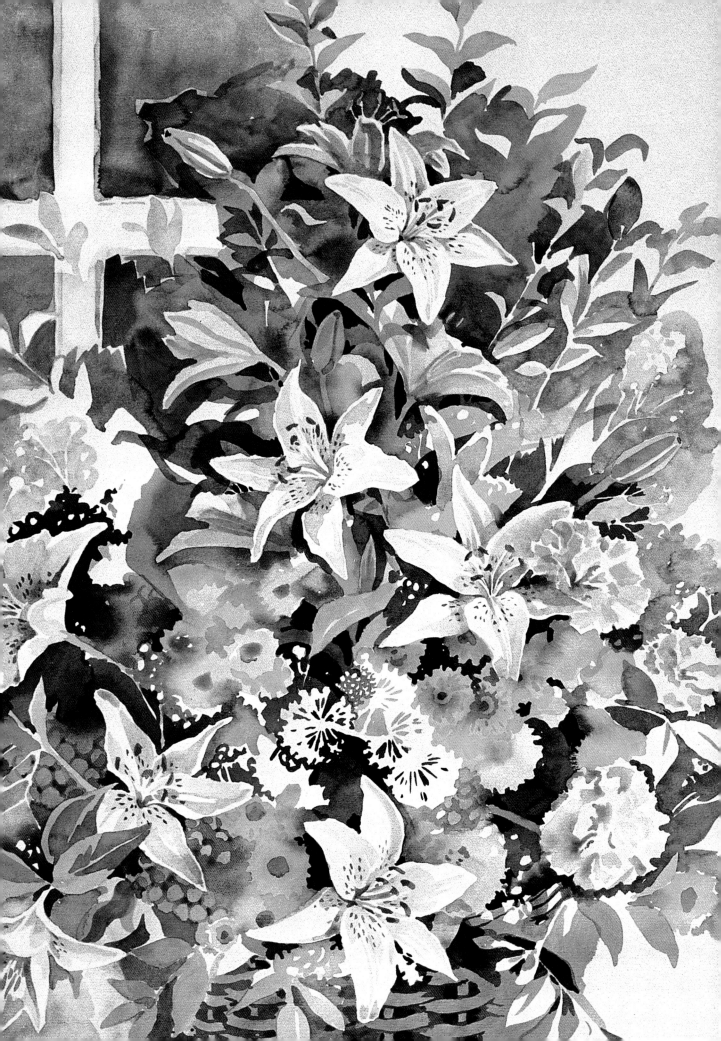

General structure

The flower head is made up of a number of parts. The tiny 'leaves' around the junction of the flower with the stem are called the calyx, and consist of a number of sepals which protect the bud before it blooms. Next comes the corolla, which is composed of a number of petals. Inside this are the stamens carrying the pollen, and inside these the seed-bearing carpels, frequently fused together to form a pistil. Not all flowers have both pistils and stamens.

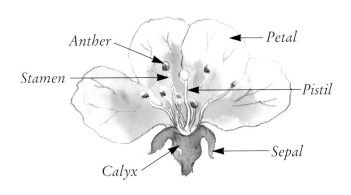

Circles and ellipses

Many flowers, whether individual blossoms, or part of multiheaded blooms, are based on a circle. That is fine when it is head on to you, but when it turns away from you or towards you it becomes an ellipse, a shape that fills beginners with dread!

◀ *Try the following exercise for practising the shape of an ellipse. Draw a square with a circle inside. Now draw the square as if it were a tile on the ground going away from you. Fit the circle into that, and, there, you have an ellipse.*

Rays and pompoms

Daisies, carnations, chrysanthemums and sunflowers are all flowers based on a circle where the petals radiate from a central point. With pompoms, clusters of petals form a raised dome or spherical shape. Do not try to paint every petal, but note the overall light and shade of the shape first to create the form, and then pick out a few petals to give the appearance of many. The lit side may need no detail at all.

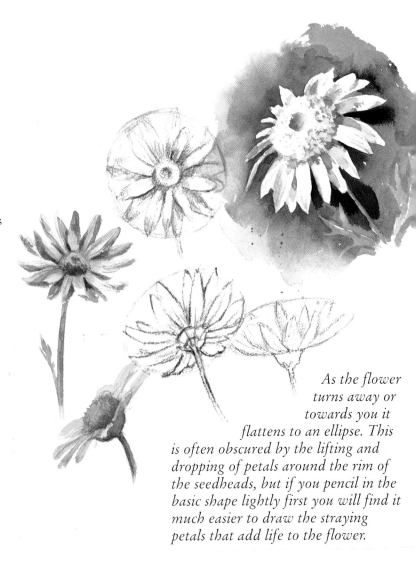

As the flower turns away or towards you it flattens to an ellipse. This is often obscured by the lifting and dropping of petals around the rim of the seedheads, but if you pencil in the basic shape lightly first you will find it much easier to draw the straying petals that add life to the flower.

Star

In many flowers sepals and petals are uniform in size and arranged in a star-shaped configuration with a very clear centre. This may be a dark point where the petals meet or a cluster of stamens. Sometimes, seen from the side, there may be a thin petal-coloured tube joining the stem to the petals – this is a perfect excuse to run the petal colour into the stem colour, wet-in-wet.

Multiheaded

At first glance a multiheaded flower appears complicated. Instead of looking at the individual flowers, however, look at the whole, overall shape they make as a group. It might be like a loose umbrella, or a tight ball. The underside is probably dark, and one side more lit than the other. Half-closing your eyes will help you to decide which blossoms to pay attention to and which to leave understated.

Spikes

A spike is an arrangement of flowers attached at the base to a long stem. With these flowers you also need to look at the whole, overall shape, and seek out the lit and shaded side to create the general form, which might be a cone or a cylinder or even the shape of a truncheon. Again, half-closing your eyes will enable you to decide which details to pick out to express individual flowers amongst the many on the bloom.

If the painting gets too fussy unite it with a pale overall wash.

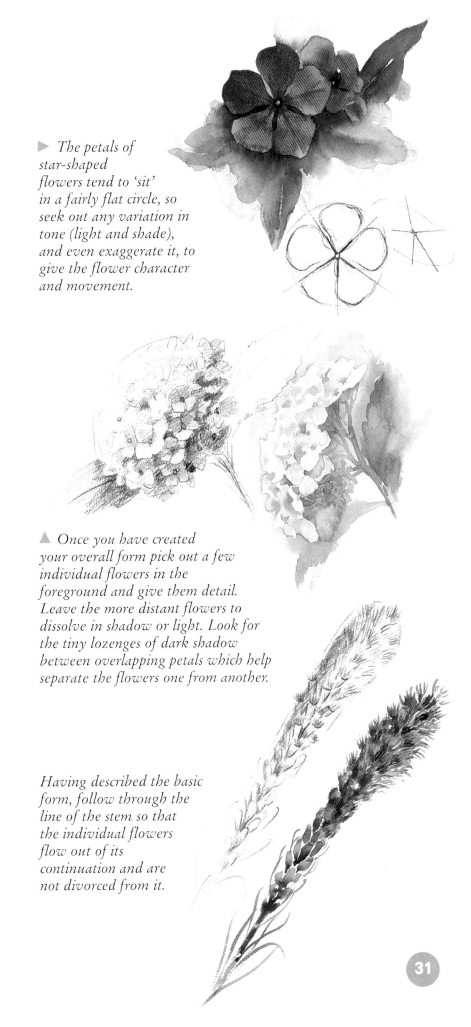

▶ *The petals of star-shaped flowers tend to 'sit' in a fairly flat circle, so seek out any variation in tone (light and shade), and even exaggerate it, to give the flower character and movement.*

▲ *Once you have created your overall form pick out a few individual flowers in the foreground and give them detail. Leave the more distant flowers to dissolve in shadow or light. Look for the tiny lozenges of dark shadow between overlapping petals which help separate the flowers one from another.*

Having described the basic form, follow through the line of the stem so that the individual flowers flow out of its continuation and are not divorced from it.

Cup and bowl

Of all flower shapes this group is probably the most favoured by artists. Roses, poppies, anemones and waterlilies are some of the flowers that can be simplified into either a bowl shape or, when less wide open, a cup shape. The wonderful interplay of light and dark within the 'bowl' and on the petals themselves, gives huge scope for practising colour and tone in watercolour. Wet-on-dry techniques build up the tones with overlaying washes of colour, and touches of wet-in-wet plunge darkness into the base of the petals. This shape is truly a watercolourist's dream.

Trumpets

Trumpet-shaped flowers, such as the lily, fuchsia or hibiscus extend from a narrow tube into a flare. The flare is often circular when seen head on, and becomes elliptical as it turns to the side. These flowers are a delight to paint as they force the artist to use strong dark colour for the centres, quickly creating believable form.

▼ *Whatever the angle of the flower the basic cup or bowl shape is clear to see. It is easy to establish if you contrast the light 'rim' against the darker centre and pick out the shadow on the underside of the petals. Use ellipses to help you draw the rim and paint light against dark to separate overlapping petals one from another.*

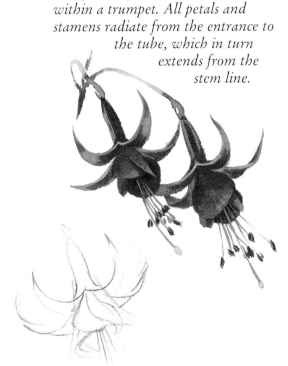

▼ *A fuchsia flower is a trumpet within a trumpet. All petals and stamens radiate from the entrance to the tube, which in turn extends from the stem line.*

◀ *Describe the cylindrical shape of the 'trumpet tube' with shadow. The deep interior is very dark, and the petals lightest as they turn away from the rim of the trumpet. Each petal must curve into a central point, and any stamens will curve out from the same point.*

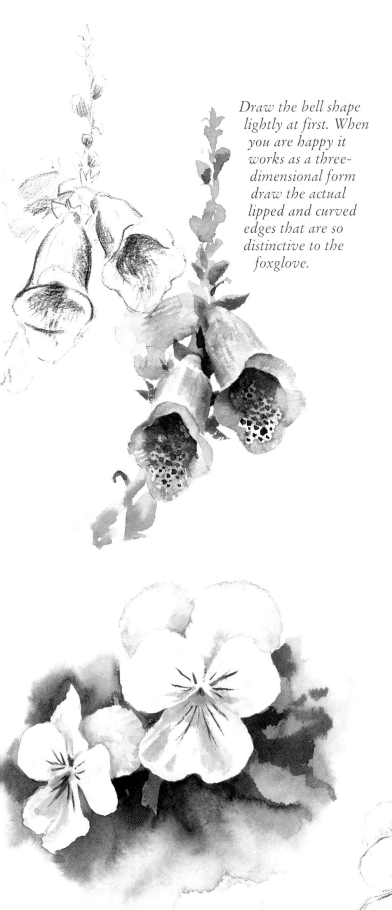

Draw the bell shape lightly at first. When you are happy it works as a three-dimensional form draw the actual lipped and curved edges that are so distinctive to the foxglove.

Bells

Whereas trumpets tend to be upturned, bells usually hang down. Once again a dark inner centre contrasts against a lighter lip of petal edges, immediately suggesting the three-dimensional form. The tube of the bell will probably be darker on one side than the other and can be emphasized to express its roundness. The stem joins the flower from the top and any visible stamens will lead on from this despite being obscured by the outer petals.

Lipped and bearded

Irises, orchids and pansies fall under this category. They look complicated at first, but in fact are symmetrical. Draw a line down the centre and you will find a mirror image on either side. Careful observation will enable you to sort out the arrangement of petals as they draw together at the centre of the flower. A contrast of lighter colour for topmost petals, painted against darker colour for the shaded parts of petals underneath, will identify individual petals and prevent the flower turning into a muddle.

Clearly defined shadows behind the top petals differentiate them from those underneath, making it easy for the viewer to 'read' the flower.

Leaves and stems

For the flower painter the leaves and stems are the perfect foil for portraying the glory of the flower; they are the chief means you have for bringing out the colour and shape of the flower. For the plant they are the lifeblood. The leaf is the principal food-making organ of the plant, and its green colour is due to the chlorophyll used in photosynthesis (converting water and carbon dioxide into the carbohydrates for growth).

The leaf has two main parts, the stalk, or petiole, and a flat blade. There are two basic types of leaf, the simple leaf, which has a single undivided blade, and the compound leaf in which the blade is composed of several leaflets.

▶ *Take advantage of the different shapes of leaves and their myriad shades of green. Apply your paint wet-in-wet, wet-on-dry, or dry-brush to bring out the character of the leaf. Whether simple or compound the direction of the petiole (stalk) and veins are the lines that count for the artist. These give direction and movement to the leaf.*

Many leaves have additional pigments, and leaves that display more than one colour are termed variegated. Wet-in-wet brush strokes are the perfect way to portray the gradual change of colour across the blade. When painting these leaves take advantage of the tip of your brush to pick out serrated and indented edges.

▶ **Lilies and Delphiniums**
75 x 91 cm (30 x 36 in)
Linda Bennion
Despite the random appearance of the mass of leaves the artist has positioned each one intentionally to enhance the whole display.

1 Create the roundness of the stem by making one side lighter than the other and grading the tone in between. You can do this wet-in-wet, by dry-brush or by stroking the paint across from the dark side.

2 Make the stems lighter than the background by painting darker colours either side. Experiment with lifting out and masking to create light stems.

3 Use the body of your brush to lay whole leaves in one stroke and bring the leaf out from the stem with your brush stroke in the same direction that the leaves appear to grow.

4 Contrast light against dark to create overlap.

Believable structure

Leaves are attached to stems in a regular pattern either by the base of the stalk or wrapped around like a sheath. Unless you are making precise flower studies much of the attachment of leaves to stems may be obscured, but it is important for the viewer to believe that your painted flowers are supported by their stems. Even if hidden imagine the stem line continues to the centre of the flower. Simplify the jungle of interlocking lines; pick out just a few and follow them through.

practical tips

❀ You do not need to detail everything for the viewer. Simply suggest and the rest will be imagined.

❀ Most is said by minimum means.

Blue Skies with a Splash of Pink
56 x 76 cm (22 x 30 in)
Shirley Harrell
The leaves and branches provide the perfect foil for the delicate pink blossom. A few descriptive lines and strong tones establish the roundness and strength of the trunk. Emphasize with detail just a few of the leaves you see, and brush in the rest with single washes, considering only the overall shape and tone.

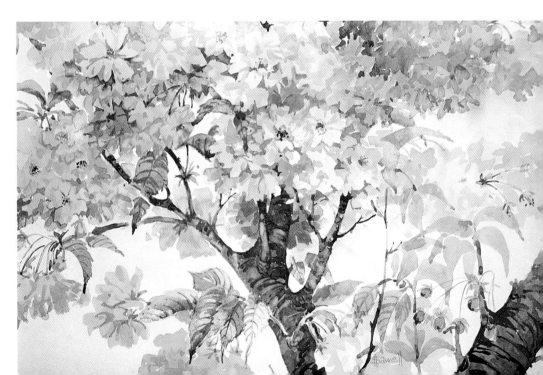

gathering Information

When I was a child I remember **gathering** wild flowers from beside the road and beneath the hedgerows. We would take them home and press the most **beautiful** ones between the **leaves** of unread books. On occasion, I have opened some of those tomes to be **greeted** by an **exquisitely** flat flower falling from the yellowing pages. The picking of wild flowers is, in many places and for good reason, now forbidden, so how much more **thrilling** to be able to go out and **gather** those flowers as paintings in a sketchbook, and as drawings and notations, already flat and **preserved** for **generations.**

chapter five

THE THRILL OF THE MOMENT

Painting in a **sketchbook** takes the pressure off making the **perfect picture**. These are **visual notes** for you alone, to be used in later paintings, or **just for the fun** of observation. And you are not limited to sketching; photographs are **very useful** to the artist, both in **saving time** or catching an unrepeatable **moment**, and as a compositional device. They enable you to work **at any time** on outdoor themes, and in the quiet of your studio uninterrupted by inclement weather or passers-by.

Building up a **reference** of sketches, photographs, pictures or even words and poems will all add to the **joy** of gathering information.

South African Sketchbook
On one page of a sketchbook you can record a great deal.

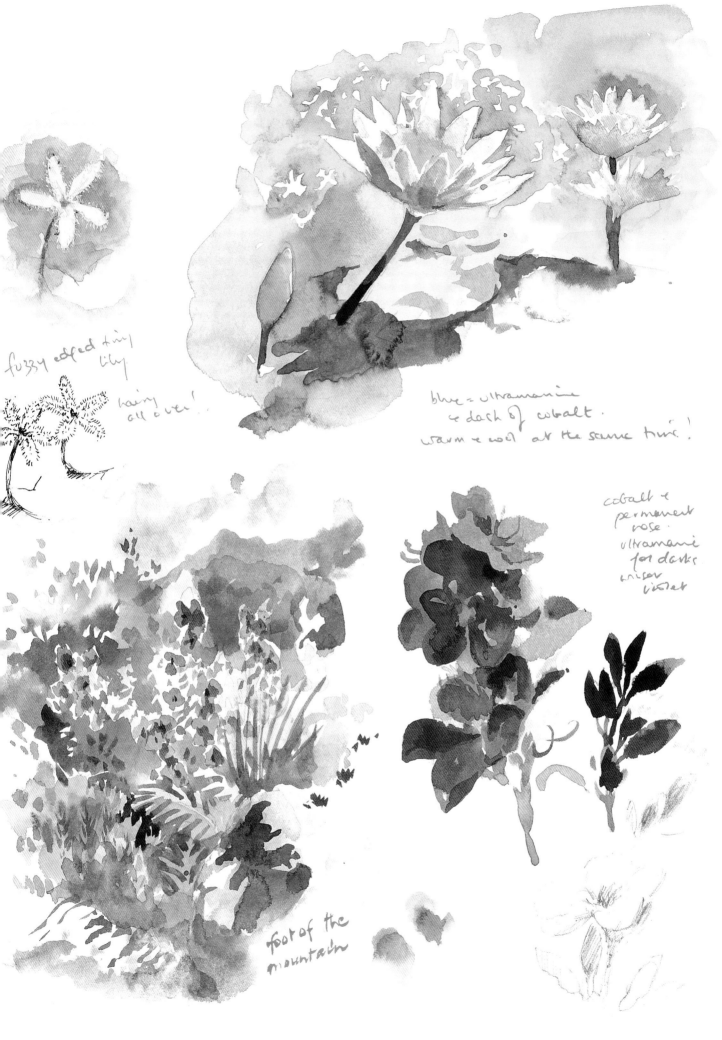

fuzzy edged tiny lily.

hairy all over!

blue = ultramarine & dash of cobalt. warm & cool at the same time!

cobalt & permanent rose. ultramarine for darks mixer violet

foot of the mountain

Keeping a sketchbook

Sketching is exploring – with the brush instead of the backpack! In the tiny realm of the flower you will find all sorts of unimagined adventures. Travel light with just a sketchbook, a pencil, a small palette of paints, one brush, and a small container of water.

Go out and wander among your chosen subject, sketching and recording only those details and impressions that interest you or catch your attention. Sketches are not finished paintings, just visual unselfconscious notes. You might just be interested in a comparison of colours, the particular shape of a gap between a leaf and a stem, or the insect that always lands on the flower you are painting! Whatever it is, just note it down – as a sketch, or a colour study, or even just a written note. The beauty of this method is that it teaches you to observe what is less obvious.

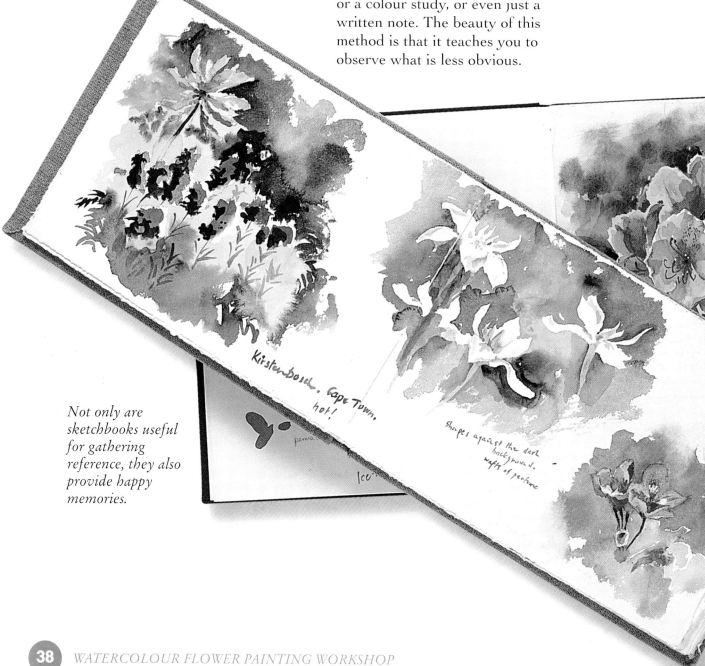

Not only are sketchbooks useful for gathering reference, they also provide happy memories.

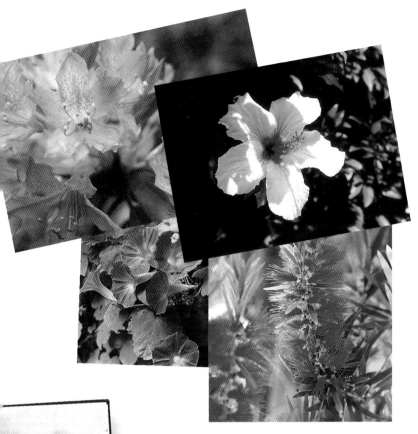

Using photographs

The camera is another useful tool for gathering information. Contrary to popular belief, however, it is far harder to paint flowers from photographs than from the real world. This is because the lens cannot be selective; it must record everything in view and it does not know what interests you particularly. So when you look at the developed photographs they often appear different from your visual memory. Nor can the camera record all the subtle changes of colour and tone you can see with your eye. Thirdly, in painting from life you reduce the real world to the size of your painting, but you have to enlarge the photograph. Very often in practice you will find you actually paint flowers life-size if you are working close up.

However, the camera is definitely an asset. When you work from the photograph, be selective. As in the real world look for the main lights and darks in the subject. Do not feel a slave to the picture, but pick and choose different aspects, move the composition closer together, or further apart. Often you will find that a garden filled with blooms has less colour in the photograph than you remembered. In that case forget the photograph, remember your experience, and exaggerate the number of flowers to fit in with your memory. Enlarge the blooms to give them the prominence they presented to you. The secret is to use the photograph; do not let it use you.

If you want to make useful flower photographs to paint details from you will need a lens that can work on a macro setting, or at least very close up. For the wider garden or landscape view get down low and include flowers right up close in the foreground. Take two photographs, one with the foreground flowers in focus, and one with the middle or background in focus. That way when you get home you will have enough information for your painting.

practical tip

❀ Use empty film cartridge containers for carrying water. The lids are watertight, and a couple of containers full of water eliminate the need to carry a heavy bottle.

Composition

The effect of a painting depends on its **composition**. The **placing** and **proportion** of the subject on the paper and the spaces around it are crucial to the painting's **success**. Composition is the **layout** of the **image** on the page, **the design** of the painting. It can be **pleasing** or jarring, **interesting** or boring, predictable or **unexpected**. As the artist you have **total control** over the composition and by it your painting will stand or fall. In practice you will find choosing a composition is often **intuitive** and sometimes quite obvious.

UNDERLYING STRUCTURE

Good composition provides the picture with an underlying structure that creates a sense of **satisfaction** and **stimulation**. For many this comes naturally, and you can usually tell by looking at someone's photographs whether or not they are aware of **good composition** by the way they frame their shots. An **awareness** of what makes an **interesting** composition can be learned, and the following chapter offers pointers in that direction. There are no hard and fast rules, however, so if you feel it **'looks right'**, just go ahead and **trust your instinct**. Children have no theoretical knowledge about composition and yet often they organize their drawings and paintings in such a way that they please the adult eye.

As I Walked Out
75 x 55 cm (30 x 22 in)

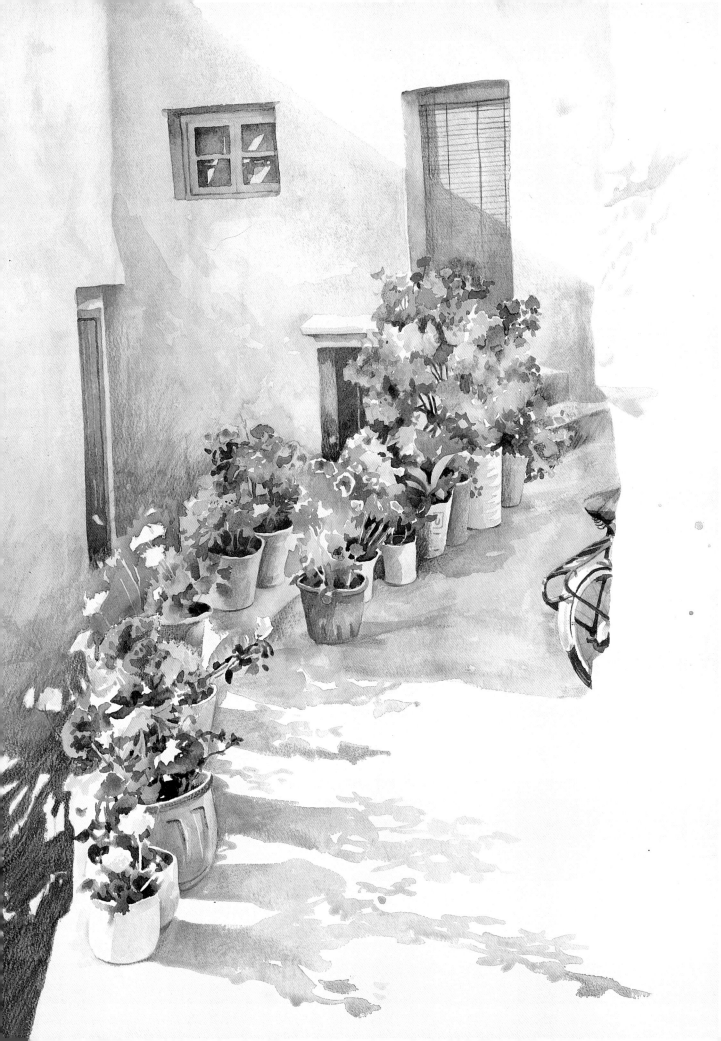

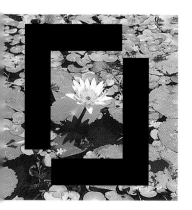

As you look through the viewfinder, move it towards and away from you, and to either side. The flowers might look better overflowing the page, or surrounded by foliage, background or space.

Getting started

Sometimes you see a clump of flowers, or a vase by a window that beckons you to paint. You do not even have to think twice before starting to lay out your drawing on the paper in preparation for painting because all the elements are in the perfect position already; a ready-made composition is at hand. Pause a moment and try to decide what makes it such a good composition. This could help you the next time when you inevitably find yourself moving round and round the subject, up and down, trying to find the right view of it to paint.

Using a viewfinder

Put the thumb and forefinger of your left and right hand together to form a makeshift rectangle. Look through this to help find satisfying compositions in the landscape or as a still life. Two L-shaped pieces of cardboard held together to form varying shaped rectangles make an even better viewfinder because you can alter it to the same proportions as your paper. If you work to a standard proportion cut yourself a rectangular hole out of a piece of stout card and look at your subject through this.

Designing the picture

An interesting composition is based upon the satisfactory positioning of the main elements within the painting, the use of tone (light and dark) and the

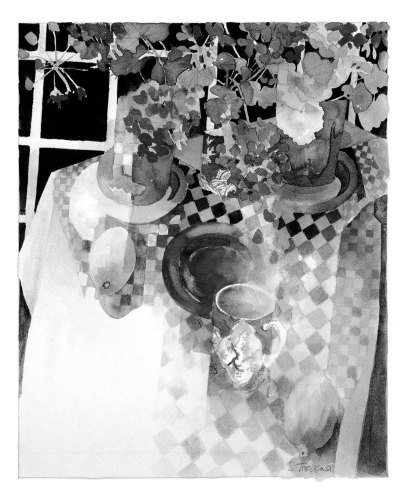

Geraniums on a Check Cloth
50 x 40 cm
(20 x 16 in)
Shirley Trevena
In this exhilarating composition all the elements of still life and window panes lead up to the geraniums at the top. But, we are not left there; immediately our eye is brought back down through the red flowers and the dropping petals to explore the whole painting.

arrangement of colour. It is about balance and contrast and involves a number of concepts:

1 A Focal Point – the main focus of interest.

2 Unity – all the individual elements must look as if they belong together.

3 Contrast – include opposites that enliven each other.

4 Variety – create interest in your picture.

No time spent in planning a composition is wasted. You will soon discover that actual painting time, when the brush is on the paper, is fairly short compared to preparation time and observation. You can lay confident brush strokes if you know where to put them. Much of a beginner's dalliance is due to genuine lack of direction. In the eagerness to begin, you may rush headlong into the painting without actually knowing where this and that colour should go, desperately hoping that by continually dabbing brush strokes the picture will come right with sheer perseverance.

Not all compositions need to be equally balanced. Daring compositional arrangements can also make exciting paintings, but still a sense of balance will prevail.

Focal point

Most paintings need a focal point. This is the principal area of interest, the element that excites you visually, and it may well evoke the title of the picture. The focal point can be placed in the centre, but it is easier to create interesting compositions by moving it to the

Winding Pathway to the Sea
40 x 51 cm (16 x 20 in)
A pathway is an easy way of leading the eye to a focal point. A quick sketch ensures the composition hangs together.

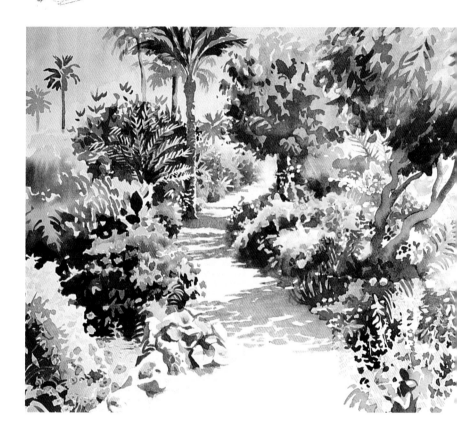

side, and slightly up or down from the horizontal centre line.

Look through your viewfinder, point your finger into the middle of the focal point, and note where it is in relation to the edge – halfway down, a third up etc. Find that same point on your paper and draw out from there. In that way your focal point will be the basis for the whole painting, and you can draw everything out from it, and in relation to it.

Unity

Repetition of lines and shapes in a painting binds it together. A main body of stems writhing in a general diagonal across the paper would look more dynamic than a haphazard criss-crossing of lines. One sure way of creating unity in your painting is to use only a few colours. Make your greens from the yellows and blues you have used for the flowers and darken the shadows of the leaves with the colour of the petals.

Contrast

A painting in similar colour and tone would probably look boring, so we need to introduce a degree of difference. Contrast of colour is always dynamic – a field of yellow daisies crossed by mauve shadows, or set against green, for instance.

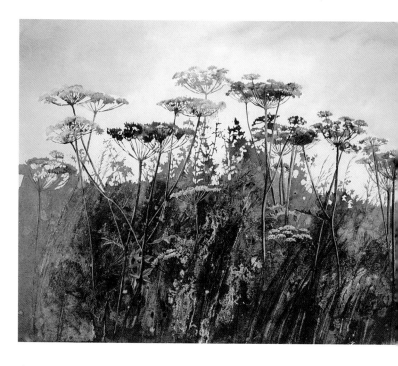

▲ **Hogweed**
52.5 x 70 cm (21 x 28 in)
Ann Blockley
The unity of colour is obvious in this painting, but combined with repetition of line in the stems and direction in the undergrowth a very strong composition is achieved.

Magnolia and Striped Rug
42 x 62 cm
(16¹/₂ x 24¹/₂ in)
Lucy Willis
Contrasts animate this painting. There is contrast of tone between the shadow and the sunlight; contrast of shape between the straight lines of the cloth and the curves of the flower; and contrast of pace between the activity of the top left and the calm of the bottom right.

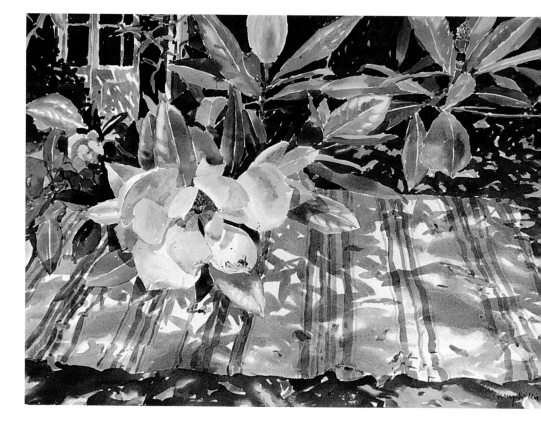

But you must also be aware of the contrasts of tone, the lightness and darkness of the chosen subject. Half close your eyes and seek out the main areas of light and shade. Small bright highlights will sing out against passages of dark colour.

A painting needs a contrast of pace, areas of activity and areas of peace. Beginners often overcrowd their paintings with so much activity that the eye gets confused and loses interest.

Variety

Thankfully God has done most of the work for flower painters! The flower heads rarely sit in rigid rows, but turn their heads in a variety of ways, offering a variety of shapes. Blooms are decorated with a variation of colour, pattern and texture.

Variety is often subtle; a painting of all white flowers is stunning if you seek out the many different 'whites' created by variation of tone.

practical tip

❀ Hold your work up to a mirror. Seeing the composition in reverse immediately shows up glaring mistakes.

Garden Romance
40 x 52.5 cm
(16 x 21 in)
A variety of colours and shapes enlivens this garden view, and a variety of techniques is used to portray the flowers and trees. Wet-in-wet background washes present a soft foil to the hard-edged masked-out foreground flowers and leaves. Detail alternates with looser washes.

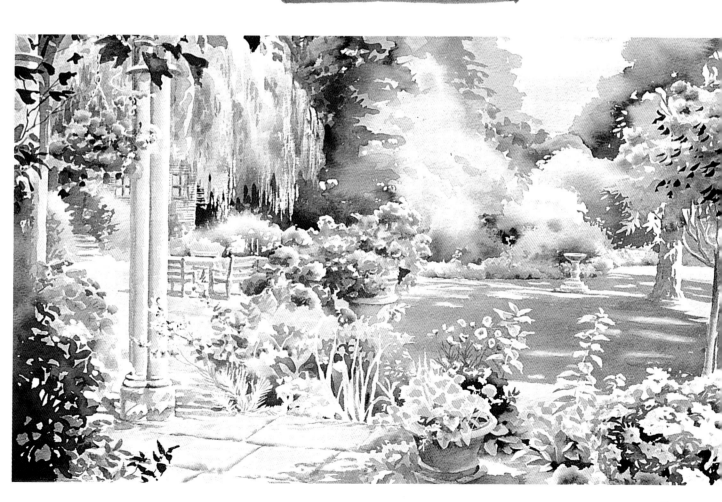

project

Colours: Alizarin Crimson, Yellow Ochre, Hooker's Green Dark, Sap Green, Ultramarine Blue and Cerulean Blue

Paper: 300gsm/140lb Saunders Waterford Not surface

Size: 55 x 37.5 cm (22 x 15 in)

Equipment: Viewfinder, size 5,7 and 12 round brushes, natural sponge, palette

For my first two compositions I looked across the lotus flowers, choosing a high horizon (top left), then a low horizon (top right). The former features more of the leaves and flowers and a hint at sky, the latter a lot more sky and less of the flowers. Next I looked down, so that the horizon was above the picture itself (bottom left). Distance is created by painting the furthest leaves with less detail and stronger colour in the foreground. Lastly, I came in even closer (bottom right) so that the lotus flowers themselves became the subject matter (bottom right).

Using a Viewfinder

Every view offers several possible compositions. Choose a location or subject you enjoy. I found this lotus garden in Korea a fascinating place to experiment with different views of the same subject.

Without shifting your position move your viewfinder around the subject. Raise and lower it so that the horizon line crosses the view, above and below the centre line. Move it to the right and left. Include a lot of sky, then a little sky. Make sketch notes of any compositions within the frame of the viewfinder that you find interesting or satisfying. Now aim the viewfinder down below the horizon line, so that the

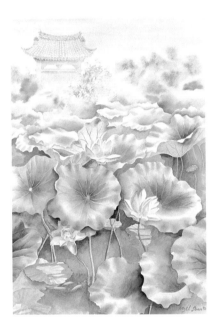

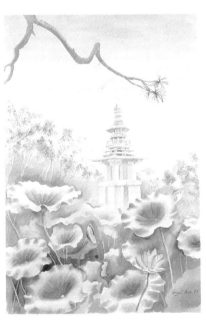

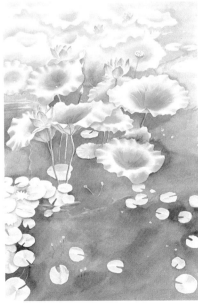

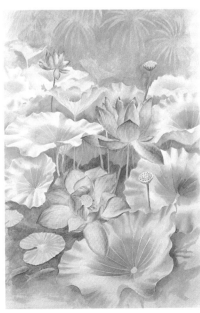

subject itself fills the frame. Move it back and forth to expand or contract the view. Lastly, move position or turn around and look back the other way. This was not actually possible in my case or I would have fallen in the water! But the idea is to double-check that you have chosen the best position to paint from. Often we pick a subject lit from the front only to find when we turn around that it is more interesting lit from behind.

Pick the best of your sketches and make small paintings on the spot of the different angles and compositions that attracted you. If you are short of time try to create the compositions through the camera lens so you can work from them later.

Turning away from my original view I looked down towards a bridge and found yet another interesting composition. This time the lotus flowers enter the picture from the lower right-hand corner and the bridge balances the view on the upper left.

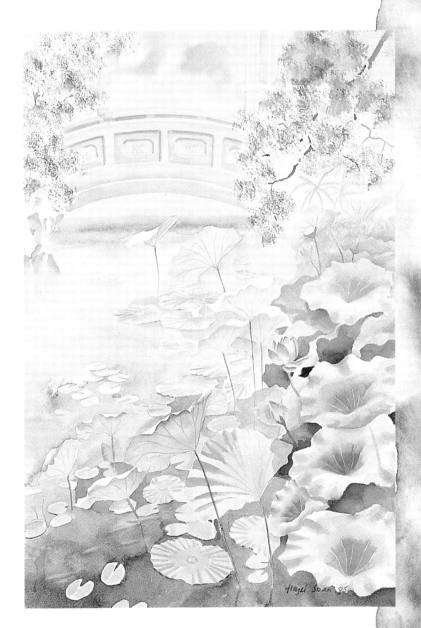

self-assessment

✿ As you moved the viewfinder around did you also bring it towards and away from you?

✿ How many satisfactory compositions did you make from your position?

✿ Which compositions would you consider making into finished paintings?

✿ Did you keep your compositions simple?

Courageous Colour

Flowers are synonymous with **colour** – sometimes **delicate**, sometimes **bold**. Here is a subject matter like none other for **experimenting** with **colours** without fear of going over the top. Yet there is a **strange phenomenon** among beginners that makes them **paint timidly**, as if they were afraid of the **strong**, **bright colours** in their **palette**. Children do not have this fear; **I wonder** where it comes from?

To a non-painter, **courage** and **daring** might seem strange words to equate with **painting**, but those of us who wield the brush know how frightening it can be to **risk** that **darker wash**, or add that splash of **vivid colour**. It is make or break time and so often we err on the safe side for fear we cannot pull it off.

chapter seven

BOLDER AND BRAVER

An **understanding** of the **properties of colour** enables you to make educated guesses as to what effect one colour might have on another in a painting. Instead of relying on **haphazard** methods you will be more in **control** and **bolder** in your application.

I hope that this chapter will **increase** your understanding and **open your eyes** to the **power of colour**. Give your colours a chance, be **brave**, let them **show you** what they can do.

Red, Red Amaryllis
50 x 40 cm (20 x 16 in)
Shirley Trevena

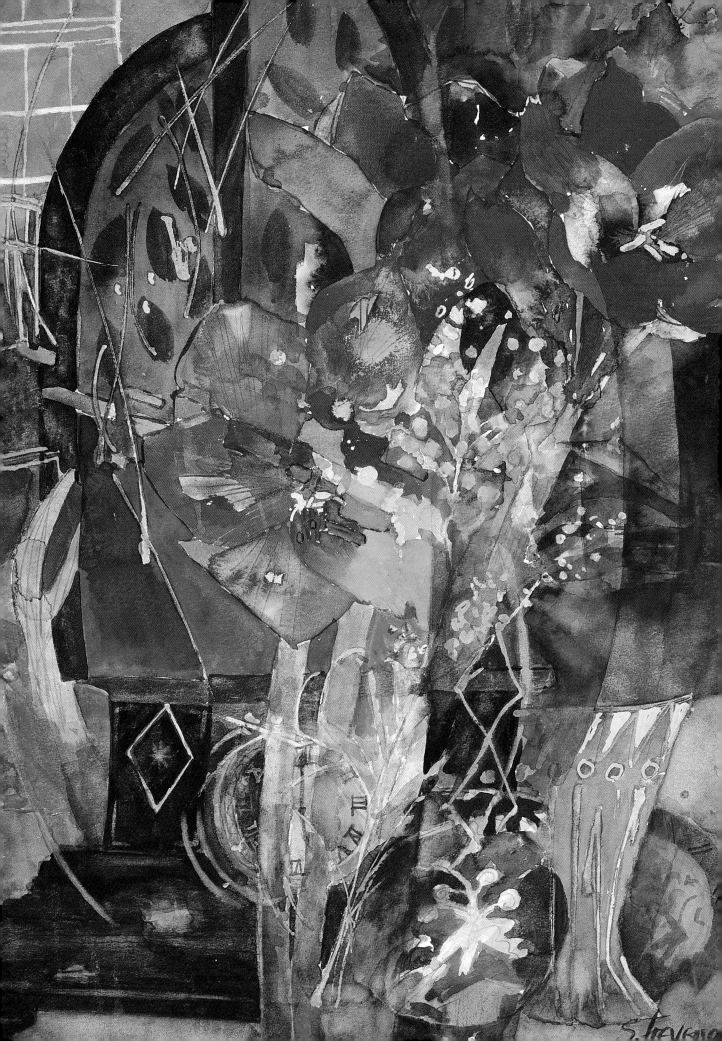

What is colour?

No colour exists without light. Colour varies according to the light that falls upon it. The colours we perceive in our world are generally seen under white light. Objects absorb some of the colours of white light (the colours of the spectrum, red through to violet) and reflect or transmit the others. We cannot see the absorbed colour, but we do see the reflected colour, the remaining colour left in the spectrum, and it is this colour that we perceive the object to be. It therefore follows that if the colour of the light changes, the object will change colour too. Hence the colours of flowers at sunset are tinged with yellow, and their shadows turn to blues and mauves.

Colour is relative

As colour does not exist separately from light, any light source can affect the apparent colour of the flower. Even light reflected off leaves or from paving will alter the colour of the items close by. You can achieve the same effect on paper when you lay colours adjacent to each other.

The colour of an object is not set in stone, and you as an artist are not bound by colours even as you see them. All colour is relative. Once you start to use colours so that they interact with each other you will be amazed how much you can 'alter' colours for the purpose of the painting, yet attain pictures that are wholly natural-looking.

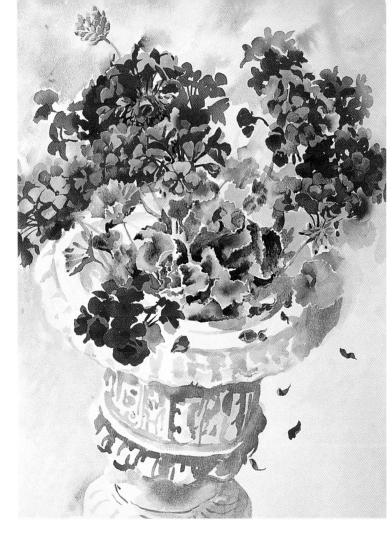

A Hot Dry Season
75 x 55 cm (30 x 22 in)
In nature you will often find strong colour contrasts between flowers and leaves. The red of the geraniums and the green of the leaves make a powerful complementary contrast.

Colour terminology

To talk about colour in relation to painting you need to be familiar with the general vocabulary that artists use to describe it.

Primary colours

The three primary colours in painting are red, blue and yellow. Any colour you want can be mixed with a combination of two or three of these. If you mix the three primary pigments together in equal parts you will make black.

Secondary colours

When you mix two primary colours together you create secondary colours – orange, green and purple. In practice, because watercolours are not made in pure primary colours you may find a more dazzling secondary colour straight from the tube. But I recommend that you practise mixing secondary colours as often as you can. The very fact that you will mix them in slightly differing proportions each time adds variation to the colour and unity to the painting.

Complementary colours

This term means to complete, or to make whole. It refers to the primary and secondary colour that when added together would include all three primaries and so complete the colour circle. Thus red is the complementary colour to green (blue and yellow), blue is the complementary to orange (red and yellow) and yellow the complementary colour to violet (blue and red).

When you mix two complementary colours together they cancel each other out and so reduce the intensity of colour. If your foliage is looking garishly green, for instance, instead of dulling it down with grey, use its complementary colour, red.

Depending on the proportions mixed, two complementaries mixed together will make rich browns, greys, or near blacks.

Daffodils
10 x 10 cm (4 x 4 in)
Shirley Trevena
By contrasting mauve with yellow the brightness of the flowers is enhanced.

▲ *Complementaries intensify each other. The yellow daisy looks more intense next to purple. The orange glows brighter against blue. The red flower looks more red against green, more orange against blue.*

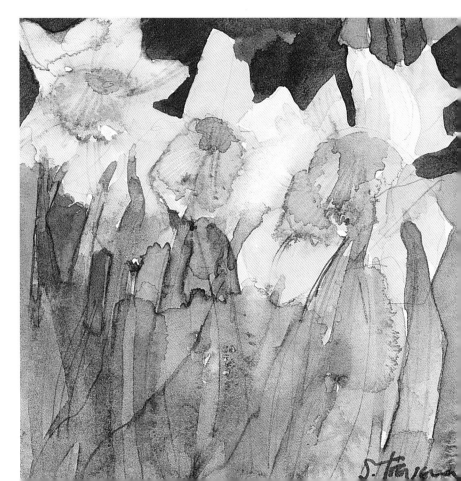

demonstration
Painting with Three Colours Only

HAZEL SOAN

It is both challenging and freeing to paint with a limited palette. To choose my three colours I looked at the reds, blues and yellows in the flowers. The mauve-pink of the peonies would need a blue-red, the blue-mauves of the scabious asked for a warm blue, and although there were no obvious yellows I still needed to make greens.

colours

Alizarin Crimson Yellow Ochre
Ultramarine Blue

▶ **1** I drew a very light sketch on 300 gsm (140 lb) Waterford Not paper, stuck down firmly on all sides with masking tape. Having squeezed some of my three colours into a palette, I washed in the basic flower shapes with dilute washes of the chosen colour: Alizarin for the peonies, Ultramarine for the scabious and monks, and I used Yellow Ochre as a warm underwash for the leaves. I was happy for the pinks and yellows to run into each other a little. I used a size 7 round brush throughout the painting.

◀ **2** I built the peonies up in patches of colour corresponding to the shapes between the highlit petal edges. I left the top highlights of the petals as white paper, half closing my eyes to get a general 'feel'. I wet the centre of the foreground peony and touched Yellow Ochre and Alizarin into this to create the glow emanating from inside the flower's depths. I took the Alizarin into the leaf areas to help create the dark leaves.

3 I created the white flowers by painting the other flowers around them, the scabious with Ultramarine Blue, the purple monks with a mixture of Ultramarine and Alizarin. On the right I used the background to create the light edges of the flowers. I shaped the monks flowers with one brush stroke, no fiddling. I mixed Ultramarine and Ochre together for the leaf colours, shaping round the peonies.

4 To describe the folds and overlaps of the white scabious petals I mixed up a warm grey from Yellow Ochre and a dash of the other two colours. I cooled this grey with added blue to darken the shaded petals.

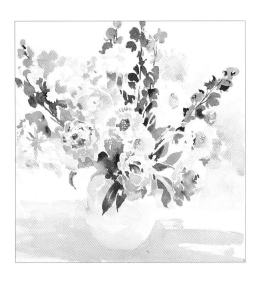

5 I built up the darker petals of the blue scabious with purple mixtures of Alizarin and Ultramarine, and flecks of pure Alizarin. To bring out the whites I washed a pale grey made from the three colours over any untouched background. At first it was too dark so I used a damp sponge to lift off the colour until only a tint remained. To establish the vase on the ground I laid a dark shadow, mixed from Ultramarine and Alizarin, which when washed over the Ochre ground turned to grey.

Old-fashioned Flowers
35 x 35 cm (14 x 14 in)

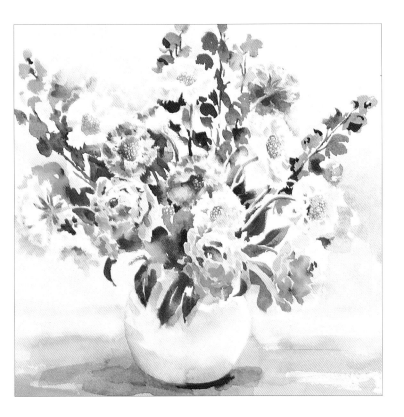

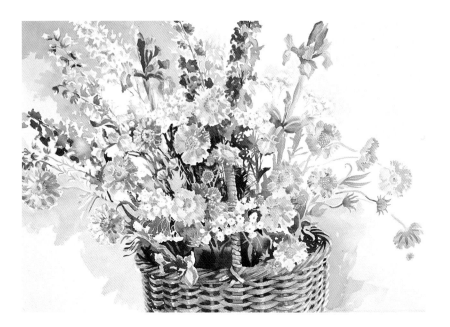

Summertime Blues
55 x 75 cm (22 x 30 in)
Cornflowers, irises, and stocks combine to create a harmony of blues, blue-mauves, and blue-greens. If you lack colour confidence choose a group of harmonious-coloured flowers and let nature do the work for you.

▼ *A monochrome study of a complicated scene enables you both to sort it out tonally and to simplify the various elements.*

Harmonious colours

Colours that are similar because they share a common base colour are called harmonious. Blue, blue-green and blue-violet all have blue in common. A painting using harmonious colours gives a visually pleasing result.

Local colour

This is the colour of the subject under white light, without shadow cast upon it. The local colour of a flower might be white, but against a light background you might find you need to paint that flower in blues or greys.

Hue and tone

The name of the pure colour is called its hue. Tone is the term used for the lightness or darkness of a colour. If your painting was reproduced in black and white you could clearly see the tones you have used.

Tonal contrast is a powerful tool to help colours stand out.

Light flowers will glow brighter against a dark background. A pale petal will show up if you darken the one behind. Remember: 'light against dark, dark against light'.

Mood and temperature

After a century of psychoanalysis most people are familiar with the concept that each colour has a different emotive effect. Reds and yellows excite us, while blues and greens have a calming effect. Reds advance and blues recede.

Colours also have temperature. Reds are warm and blues are cool. But colour is relative, so a red that veers to blue, such as Alizarin Crimson, will be a cool red (because of the touch of blue in it), even though it is a warm colour in relation to blue!

If you are mixing two colours together with the intention of maintaining their brightness, check that both colours have the same temperature tendency. Cadmium Red and Cadmium Yellow are both warm, so the resulting orange will be bright and warm too. But if you mix Cadmium Red and Lemon Yellow together, because Lemon Yellow is a cool yellow, the resulting orange will be less bright.

▲ **Guernsey Poppies**
15 x 20 cm (6 x 8 in)

▼ **Okavango Lilies**
12.5 x 20 cm (5 x 8 in)

Compare the warmth and energy emanating from the little sketch of vibrant red poppies above with the cool, calm and soothing effect evoked by the blues and greens of this water lily painting. Colours have mood and temperature, so exploit this to create the effect you require.

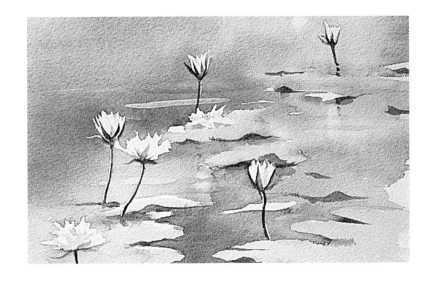

exercise

❀ Place different-coloured flowers against brightly coloured papers and paint the combinations that appeal to you most as loose colour sketches. Are they complementary colours, harmonious colours, or contrasting tones?

Interaction of colours

As we have seen, no colour works in isolation. The artist must use the properties of colours, one against the other, to emphasize the shapes, shadows and mood that are the subject of the painting.

The colour of shadows

Thanks to the work of the nineteeth-century French Impressionist painters the idea of coloured shadows is familiar to the amateur artist. As the sun sinks in the western sky, and the world is bathed in orange-yellow light, the colour of your shadow on the ground has turned to a complementary blue-mauve. Seeing colour in the shadows will enhance the beauty of your paintings.

To cast a shadow across a flower or stem it is sometimes easier to wait until you have finished painting the details. Then mix a diluted wash of colour, possibly the complementary, and with a single brush stroke lay it gently across the previous washes so as not to disturb them. This will create a translucent shadow.

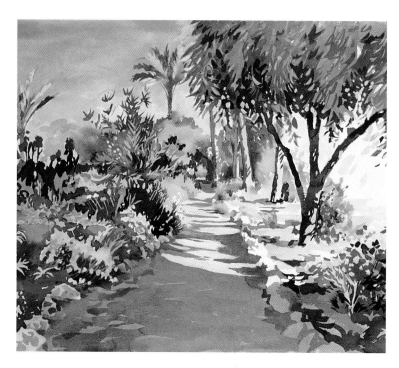

Estepona Boulevard
55 x 63.5 cm (22 x 25 in)
The blue-violet shadows were painted before any of the flower details, creating the dynamic of the composition from the outset. The shadow cast across the pathway was strengthened with a second wash.

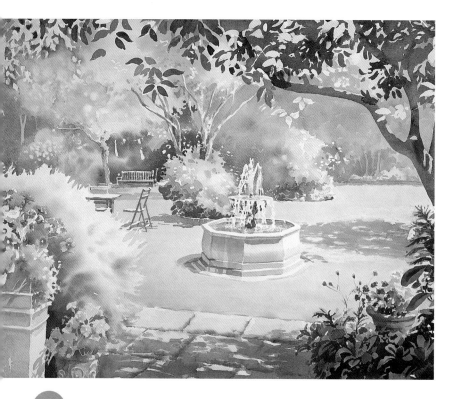

Using greens

Experiment with greens. Mix a yellow and blue you are using in the painting to create them.

If you use greens direct from the pan or tube you can alter them slightly by adding touches of colours you are already using. Ask yourself, does this green veer towards yellow or blue?

Garden Fountain
55 x 75 cm (22 x 30 in)
Sap Green (warm yellow-green) and Hooker's Green Dark (cool blue-green) are the two 'tube' greens employed in this picture. All the other greens are created by the addition of colours already in the painting.

Painting white flowers

The white appearance of petals is caused by numerous minute air pockets between the cells of the petal. White paper is the watercolourist's brightest white, so reserve white paper for the petals of white flowers.

But what if the flower is actually darker than the background? Half close your eyes, and how grey those petals will look against the light background! Do not worry – you will be amazed how dark you can paint those petals and the flower will still look white. Use blue- or mauve-greys rather than diluting black or grey paint. Observe carefully where the lights and darks fall within the overall greyness of the flower.

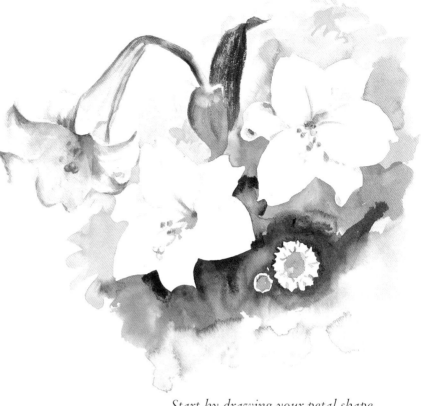

Start by drawing your petal shape first and paint its shape by the colours that surround it. Before you paint the detail, find the general lights and darks. Create the form of the flower with washes of darker tone, then build up the details such as the shadow lines between the petals as they overlap. See how dark you can paint a white flower against a light ground, yet it still looks white.

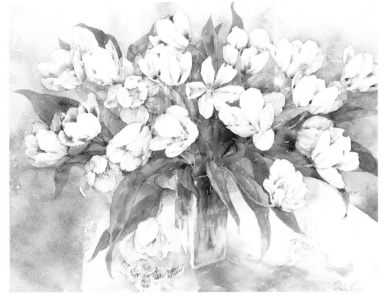

White Tulips
52.5 x 72.5 cm (21 x 29 in)
Shirley Felts
At first glance you see a vase of white tulips. Now look carefully flower by flower at the colours the artist has used to paint the white petals. Mauves, greens, ochres and blues play across the white paper to create the appearance of white flowers.

practical tip

❁ Do not be afraid of the dark! If a flower looks dull, darken some of the foliage against it and see the colour sing out.

project
by Shirley Trevena

Colours: Quinacridone Red, Burnt Sienna, Permanent Alizarin Crimson, Brown Madder, Cobalt Turquoise Light, Hooker's Green, Indanthrene Blue

Paper: Good-quality watercolour paper, Not surface

Size: Approximately 45 x 45 cm (18 x 18 in)

Equipment: Your usual brushes, a good choice of watercolours, preferably in tubes; spare paper for experiments with colour

Tulips and Irises
49 x 38 cm
(19½ x 15 in)
Shirley Trevena
The soft purple shapes of the irises are pushing out of the top of the frame. The sharp green leaves are strong; they will live on long after the blooms have gone. Only a few flowers are completely painted. A brilliant yellow holds the whole picture together and makes the other colours look even more vibrant.

Making the Colours Sing

For a successful painting choose flowers that really interest or excite you. Write a list of what makes these particular flowers so appealing and check it while you are working to make sure you retain these elements.

Decide on the main colour scheme for your flowers. Think about the flowers in an abstract way. Perhaps you may want to communicate to the viewer their wonderful perfume. How would you do that with colour? How could you show that some flowers are so delicate they only last a few days and yet others are strong and sturdy.

The viewer really only needs a few colourful marks to recognize a flower, so try to capture your feelings rather than every small detail.

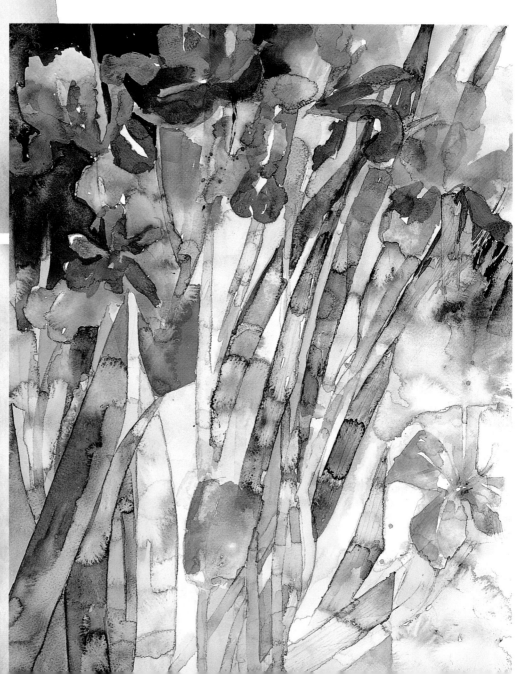

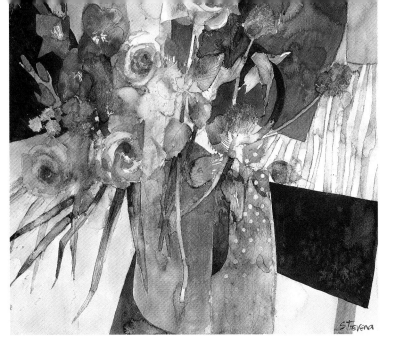

Red Flowers
on a Black Table
49 x 57 cm (19½ x 23 in)
Shirley Trevena
This painting has many pinks, reds and orange-browns. It feels so hot it almost has the perfume of a summer garden. Such 'sweet' colours needed to be balanced with the contrast of the black table and the near centre area of Cobalt Turquoise provides a brilliant focal point.

To get vibrant colours use complementaries. The Cobalt Turquoise in *Red Flowers on a Black Table* jumps out against all those pinks and oranges. You can also use the contrast of light against dark. In *Tulips and Irises* the blue-purple flowers are very strong against the dark indigo.

When painting more than one of the same flower, at first glance the colours of the petals or leaves may all seem the same. Try to avoid representing them in this way; use your imagination and instead of just one pink use several pinks going into red, purple and orange.

Sunflowers
10 x 10 cm (4 x 4 in)
Shirley Trevena
These sunflowers have very strong, straight stalks but soft, vulnerable leaves. This picture is really about the wonderful yellow of the flowers, ranging from orange to lime green, with a contrast of Cobalt Blue to suggest hot summer skies.

self-assessment

❀ Does your painting really express your original visual excitement?

❀ Have you used too many colours, losing the strength of variation of just a few?

❀ Are there enough contrasts: lights and darks?

❀ Did you get trapped in tight visual details?

❀ Did you interpret shapes and colours more loosely?

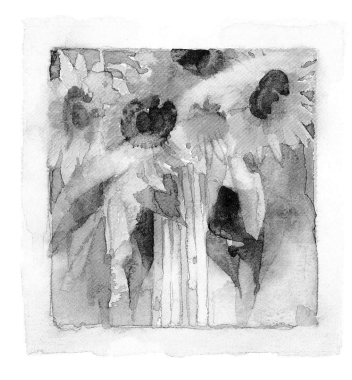

backgrounds

How many times have you painted a marvellous collection of flowers in a pot only to ruin it by putting in a background that does not work? Often backgrounds are left as an afterthought, but they should be planned as an integral part of the painting.

First, not every painting needs a painted background. Some of the most successful flower paintings are set against white paper and look stunning, especially if the colours are strong.

Second, the background need not fill the whole paper to the edges. The broken, washy brush strokes made unselfconsciously around your flowers as you painted them make interesting and lively backgrounds of their own. Their spontaneity brings a freshness to the painting.

chapter eight

INTEGRAL PARTS

For a background to work it needs to be seen as part of the picture while you are painting. Do not think of it as something separate. Use it to help create the foreground, to bring out the colours or describe the outline of the blooms. In some flower paintings the background is actually painted first before the flowers themselves. It may be empty space in the real world, but not in the two-dimensional realm of the painting.

Foxglove
38 x 28 cm (15 x 11 in)
Ann Blockley

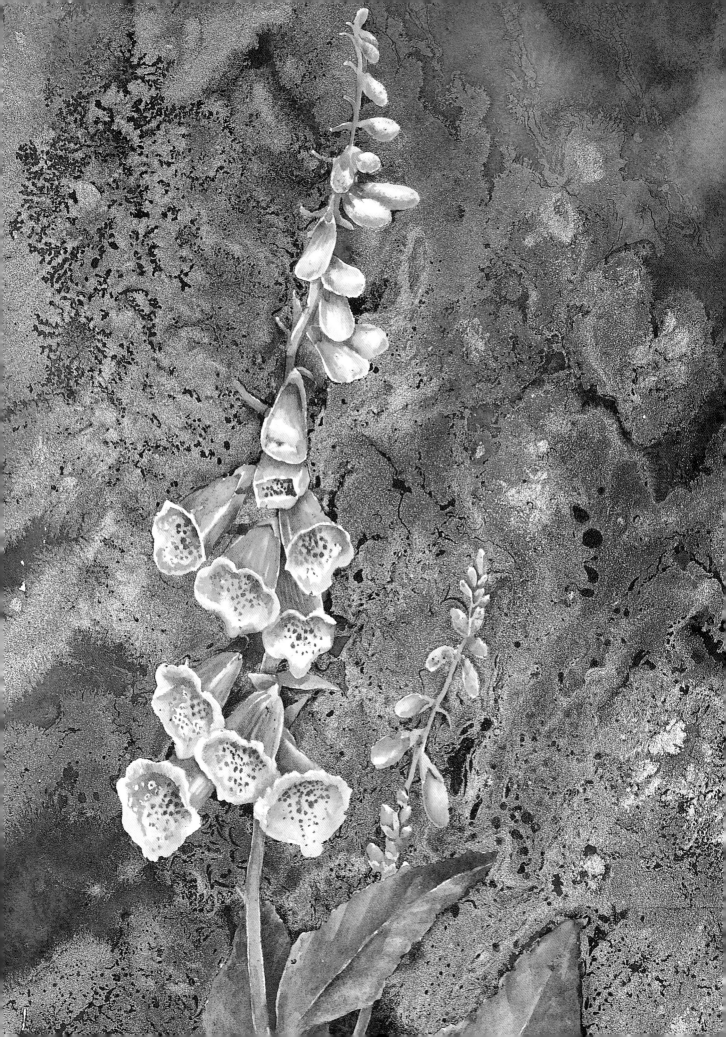

Seeing the negative shapes

When you have found an ideal subject to paint you may at first be only aware of the flowers themselves, the container, or the immediate setting. If you are using a viewfinder, imagine that the empty rectangle is a pane of glass. Trace onto that glass in your mind's eye the view you have before you. Instead of looking at individual flowers, draw their group shape against the background. Look at the wedge and lozenge shapes that make up the background around them. These spaces around and between the subject matter are termed negative shapes; use them to help you render your subject successfully.

Suppose you were painting a portrait of a face. You might get the eyes, nose and mouth exactly like the sitter's, but if the spaces between them were incorrect then the portrait would not really look like the sitter. In flower painting the shapes of these spaces will help you draw the blooms convincingly and enable your flowers and other objects to sit well with each other on the paper.

practical tip

❁ Keep your backgrounds simple. Let the brush do the work.

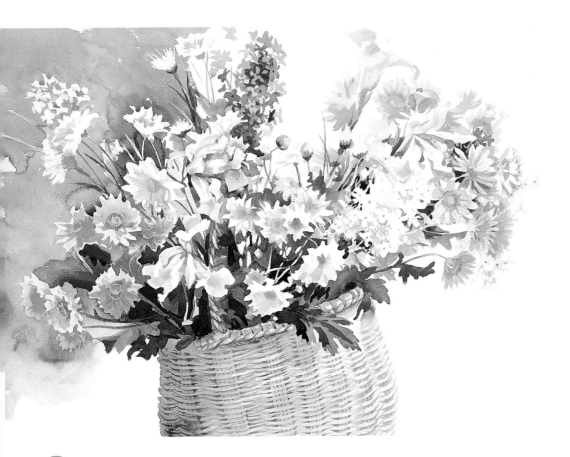

Basket of Flowers
55 x 75 cm
(22 x 30 in)
Look at the spaces between and behind the flowers; it may be foliage or background. Imagine that these spaces, not the flowers, are the subject of your painting. Here, on the left the background 'paints' the flowers; on the right the white shapes balance the composition. The dark foliage in between the flowers describes the individual blooms.

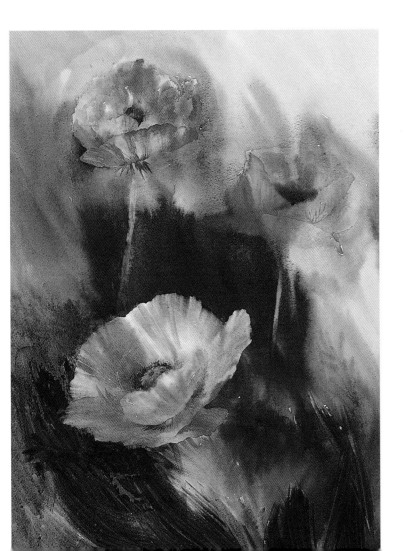

If the flowers you are painting are all the same colour, an easy way to make your painting hang together from the outset is to paint a pale wash of that colour under the whole painting, leaving any area of really bright highlight as white paper. Build up your painting with subsequent washes on top.

Poppies
38 x 28 cm (15 x 11 in)
Ann Blockley
A variegated wash suggests surrounding grasses. The poppies are immersed in a sea of swirling green. Powerful brush strokes through this wet-in-wet wash add to the upward vitality.

Background washes

The background does not need to be solid. Whether your wash is one colour or variegated, leaving flecks of white paper between your brush strokes adds vitality to a painting.

Tonal variation

The background does not have to be even. Bring out your light flowers by darkening the background immediately adjacent. For a soft gradation of tone, wet the paper first with clean water, and then brush in the colour wet-in-wet outward from the edge of the petal. In that way the darkest tone is against the light flower.

Likewise, even if the background of your painting is generally darker than the flowers, lighten it against dark leaves to help them stand out.

If the background looks too flat vary the overall tone by making it darker on one side of the paper than the other, or darken one corner, top or bottom.

Variegated washes

A strong free-flowing impression of background foliage can be made with a wet-in-wet wash. Mask out your flower shapes with masking fluid. Dampen your paper and apply bold washes of paint in colours to suggest the foliage and flowers. The lovely blurring that occurs as the paint blends wet-in-wet in a variegated wash creates the suggestion of floral activity behind your foreground flowers.

living still Life

The **beauty** of **painting flowers** indoors is that you can work under a constant light at your own pace and without interruption. Setting up a **vase or bouquet** of flowers gives you the **luxury** of time to paint slowly, absorbing every **nuance** of colour, **tone and shape**. This is the **best time** to **experiment** with colours and their complementaries, to practise seeing **different tones**, and to concentrate on **shapes** and the **spaces** between them.

If you are in your studio or home, **still-life paintings** also give you **space** to spread, and present a **marvellous** opportunity for playing with a **wide variety** of **techniques**.

chapter nine

SEEING THE WHOLE

The **most common** problem that besets beginners is the tendency to paint **everything** with the same degree of **detail** and with **similar tones** and **colour** throughout. They tend to see **each flower** or even **each petal** separately, rather than as parts of the whole composition.

I recommend that you **start with** very **simple arrangements** – perhaps just a few flowers in a vase. Even try a jam jar; although **glass** may appear difficult to paint at first, the fact that the colour of the stems carries **right through** into the container aids the **unity** of **the composition**.

Clutter
75 x 55 cm (30 x 22 in)

Flower arrangements

Almost any arrangement of flowers seems to lend itself to painting, but obviously the more attractive or exciting you find the flower arrangement the more likely you are to render it successfully as a painting. For this reason it is worth fiddling with leaves, stems and blooms to make the view you have chosen well balanced and interesting.

The still life may be a bouquet, or simply a few blooms placed on a table. Whatever you decide to paint check before you begin that the composition 'works'. I get a 'jump in the tummy', a feeling of excitement to start, if the composition is right immediately and needs no 'tweaking'. However, if I find myself hesitant, or lacking that eagerness, I reposition myself or the subject until I feel the excitement.

Care of flowers

Flowers start to deteriorate as soon as they are cut from the plant, so if you intend painting over a period of time you will need to choose some buds too. Stems start to seal when removed from water, so cut them before giving them a good drink. Peel off some of the foliage from the lower stems to help prevent rotting and to make a better composition if your vase is transparent.

It is possible to keep flowers fresher by occasionally spraying them with a fine mist of water. Keep them in a cool room overnight, or even place them in

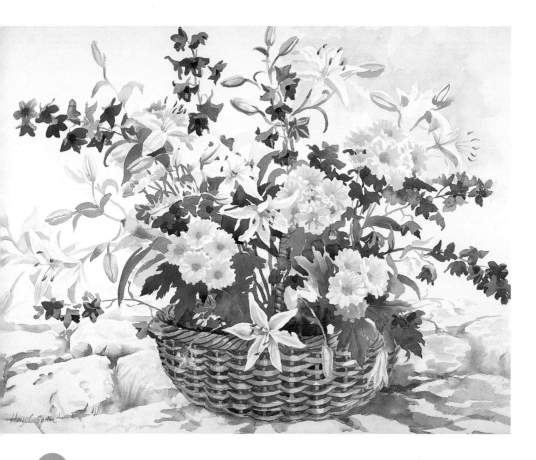

Brimming with Summer

55 x 75 cm (22 x 30 in)
The rim of the basket is broken with overhangs. The stems are pulled out away from the centre to prevent a solid mass, allowing light to come through between the foliage. The colours and shapes of the flowers are balanced, but not symmetrical; for example, note the upward curve of the white flower on the left and the downward curve of the blue flower on the right, and the off-centre position of the basket.

the refrigerator covered with a plastic bag. In a warm room flowers soon wilt. The heat from a lamp, positioned too close, will kill them too.

Choosing your view

Most people prefer to sit to paint with watercolour. If you have positioned your still life on an ordinary table you may well find the angle at which you are viewing your subject presents a view that is too 'straight on'. Low coffee tables make excellent platforms for still lifes, because you are looking down on the subject and the surface upon which the flowers are sitting fills more of the two-dimensional plane of the painting. This does not mean to say any angle is wrong or right; use your viewfinder to make your own decisions about the 'rightness' of your composition.

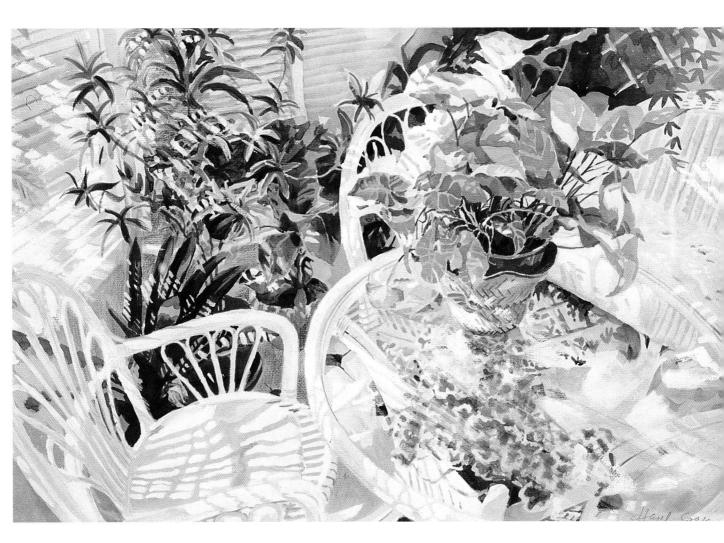

Rosie's Conservatory
47.5 x 72.5 cm (19 x 29 in)
In this painting the eye-level is above the picture. You would have to stand up and look down on the subject to paint this view. Because you are so close, the *chair and the table appear to fall away to the sides, rather like the view through a wide-angle lens. Views like this make interesting compositions, often more challenging than a conventional straight-on view.*

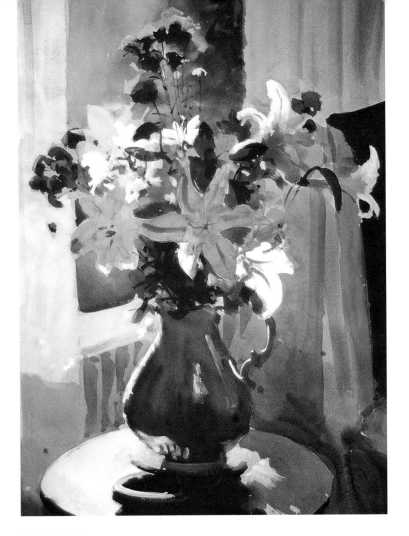

Pink Lilies
45 x 57 cm
(17¹/₂ x 22¹/₂ in)
John Yardley
Side light: *Standing the flowers beside a window will light your subject from one side, creating contrasts of light and dark.*

The Chinese Vase
55 x 38 cm (22 x 15 in)
Backlight: *When flowers are directly against a window check if the background or the view behind is darker or lighter than your subject.*

Lighting

Positioning your flowers to gain a constant light source will greatly aid your painting. Paintings, unlike photographs, are created over a period of time, so there will always be an element of generalization. Most still lifes are painted under an ambient light, but whether front-lit, back-lit, or side-lit you must note the tone of the background. If darker, however slightly, use the background colours to draw the flower shapes and bring out their colour. If lighter keep your colours bright and strong; nothing looks less interesting against a light background than insipid flowers with no variation in tone.

Painting the flowers

A rough pencil sketch will provide a guide in painting and help avoid confusion, especially if there are

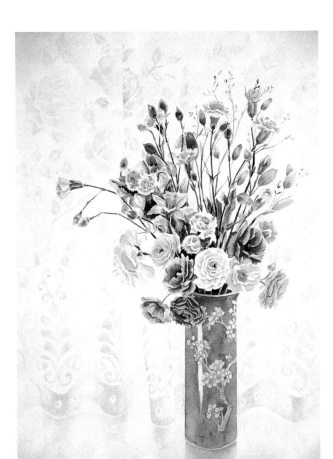

practical tip

❀ Where you have strong dark tones, be brave when putting down the first wash – your watercolours will be fresher.

light flowers in front. Pale washes of the main colour areas help to establish an overall colour, reserving light petals and highlights as white paper. Simplify the foliage between the flowers; very little is needed to suggest leaves and stems.

Once you have the main elements of the painting in place, step back, look at the picture from a short distance away, or in a mirror, and see if it works. Is the general impression clear or muddled?

Building up colour and details

As you build up the petal colours use stronger tints of the same colour. Mix the colour with its complementary for the shadows cast between petals.

You need very little detail to suggest the make-up of a bloom, so be careful not to overwork it. Observation and a distillation of what you see are crucial. The flower will not make sense if the variety of hues and tones painted are indiscriminate.

Paint the details of the flowers only after the general form is acceptable. Enhance the impression of space by darkening the foliage, especially behind the foreground blooms.

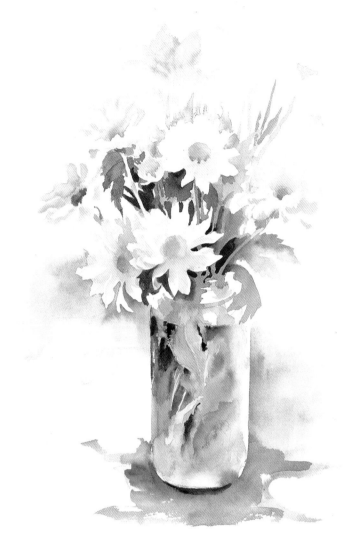

▲ Making a start: *Here Cadmium Yellow and Prussian Blue are used throughout the painting. Over a wash of yellow the blooms are picked out with the foliage and background colours.*

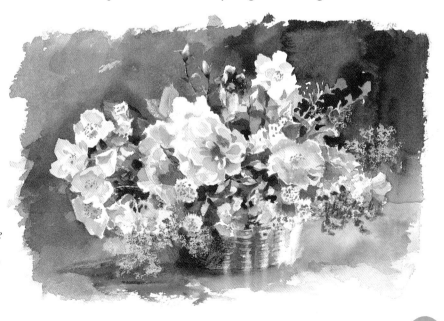

The details of the flowers are built up with small, carefully placed washes, wet-on-dry, and the background darkened around the pale blooms. Neat Lemon Yellow brings out the buds at the top and is sponged onto the dark background for the sprays of tiny yellow flowers.

demonstration
Exploring Tonal Contrast

JOHN LIDZEY

I placed the jar of flowers in a shaded corner out of direct sunlight and exaggerated the dark areas on the wall behind to provide a luminous quality to the flowers. I used silk flowers – these have the advantage of remaining static over a period of days if the painting is going to take some time.

colours

Aureolin	Indigo
Yellow Ochre	Cadmium Yellow
Monestial Blue	Pale
Cadmium Red	Carmine
Payne's Grey	French Ultramarine

▶ **1** I made a fairly careful and accurate drawing of the arrangement using a 4B pencil. I could not stand these flowers in water for obvious reasons, yet I wanted to create the effect of water in the jar. To solve this problem I stood the stems in water for one minute and made a quick sketch of the distortion effect. The rest of the painting was produced with no water. I relied on the information in my sketch to suggest the appropriate watery effect. The flower heads were painted over with art masking fluid. I do not normally like using this material very much but I think the difficulties of reserving these complicated shapes make it the better option to use.

2 The next requirement was to lay in the main colours of everything except the flower heads. At this stage I was not particularly concerned about tonal values (lights and darks) in the painting.

Notice that I laid the colours in quite loosely and achieved a number of backruns and drying marks. I used Aureolin, Yellow Ochre and Monestial Blue for the wall and Cadmium Red, Monestial Blue and Yellow Ochre for the chest of drawers.

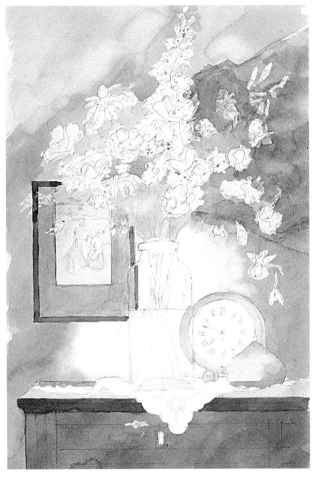

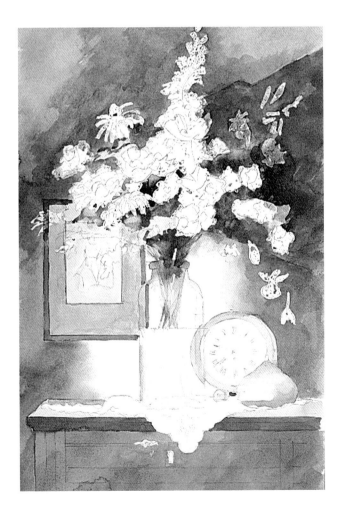

3 My concern at this stage was to darken the background before removing the masking fluid. The next washes for the wall area were similar colours as for Stage one, but I made the mixes of paint stronger and cooler with more Monestial Blue, together with some Payne's Grey.

I darkened the leaves and stalks of the bouquet using mixes of Aureolin and Indigo plus a small amount of Payne's Grey. The dark shape on the top right of the painting is a mirror reflecting a blank wall on the other side of the room. I wanted to keep this shape in view, but decided that it should appear as dark and undefined. I therefore lowered the tone of this with further washes of Cadmium Red, Payne's Grey, Yellow Ochre and Indigo.

▶ **4** Before removing the masking fluid I decided to further lower the tone of the background and also to make it slightly more blue/greenish. Because of this my next mixes for the wall were similar to those used in Stage two but with the addition of some Indigo. I kept the area behind the jar and clock quite light in tone. The soft edges were achieved by gently wiping colour out using clean water and cotton wool. The right-hand side of the chest of drawers was further darkened using the same colours as in Stage one but with the addition of Payne's Grey.

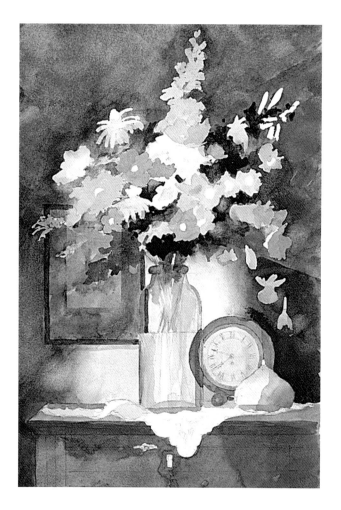

◀ **5** Having removed the masking fluid my next step was to lay pure, very dilute colours over the flower heads, just as flat washes. I was anxious to keep the colours as unadulterated as possible, so I mixed the pigments in a clean palette using clean water. The resulting flowers as shown looked particularly hard edged and not nearly like I wished them finally to be. This would be rectified at the next stage.

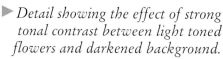

▶ *Detail showing the effect of strong tonal contrast between light toned flowers and darkened background.*

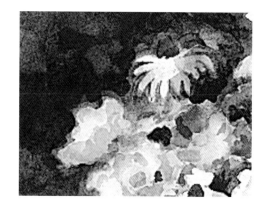

6 I softened some of the edges of the flowers using damp cotton wool with a gentle rubbing action. Using white gouache mixed with watercolour I added some of the flower stems; others were put in using strong mixtures of watercolour. For spontaneity I flicked some white gouache mixed with colour pigment over the flower area. Highlights were also added to the glass jar and the gourd. It is amazing how highlights on glass jars can be so effective in creating a glasslike effect. A final area of masking fluid was removed from the chest of drawers and suitable tones added to suggest a piece of clothing protruding from one of the drawers. Finally, a little conté cross-hatching in the top left and bottom right added intensity to the surface and completed the picture satisfactorily.

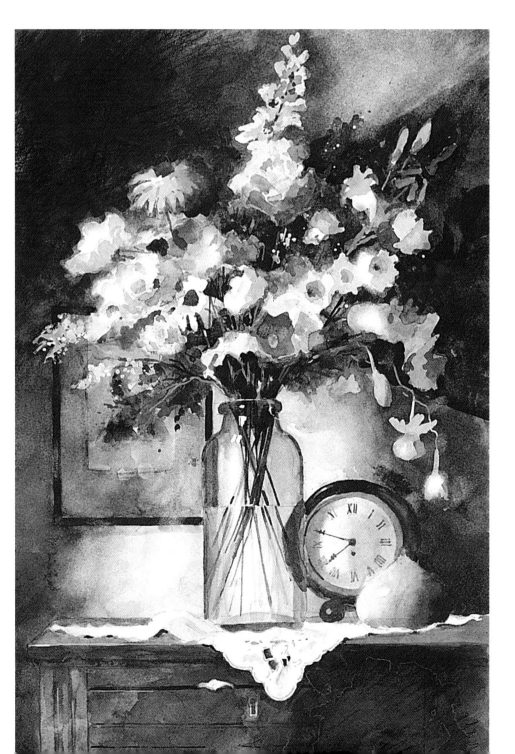

Flowers in a Glass Jar
48 x 30 cm
(19 x 12 in)
John Lidzey

Flower supports

Half the fun of painting flowers indoors is painting their containers. Give yourself a good start by choosing one you actually like the shape of, and check that the proportion of the pot to the flowers looks balanced (it can also be interesting by being out of proportion, but try this when you have more experience). Baskets also make great supports. Use oasis to keep the flowers in position.

Observe carefully, and do not presume that the light will have a particular effect. First take note of the relative tonal values either side of the pot against the background. Usually one side of the pot will be light against a darker ground, and the other side in shadow against a lighter ground, however subtle. The fact that in the real world the background may appear to be all the same tone and colour is largely irrelevant to the artist. The two-dimensional realm is literally a world of 'make believe'.

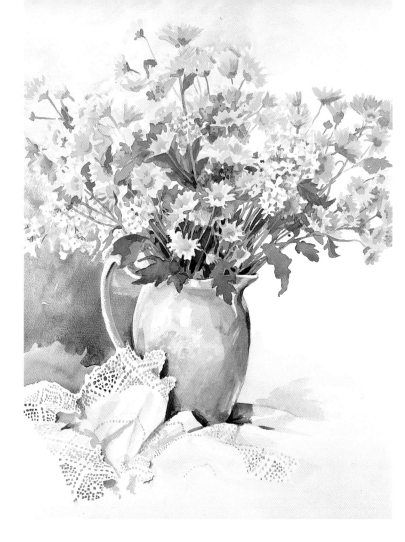

▲ **A Spray of Thanks**
75 x 55 cm (30 x 22 in)
The roundness of the pot is achieved by the use of relative tones. On the left a dark background is brought up against the light side of the jug, while on the right, against the shaded side, it remains as almost white paper. Notice the light on the jug against the shadow.

Esther's Baby
15 x 15 cm
(6 x 6 in)
Start simply: *The glass is indicated by a pale mauve-grey tone, the base simplified into a few descriptive lines, the meniscus reserved as white paper and the leaves distorted at the water line. How little is needed for the jar to look like glass!*

Transparent containers

Glass is enjoyable to paint. Even though you are distracted by the activity within, the vase or jar will still have a three-dimensional form that needs to be understood. Too many highlights on the glass tend to be distracting. Your job as the artist is to represent, not copy, so decide which are the main highlights (half close your eyes to see them) and leave out the rest.

This same selection of appropriate details applies to the stems within the glass. Soften the detail with some wet-in-wet washes if the painting is looking too complicated. Pick out the main lights and darks and the directions of the boldest stems.

Indicate the curved surface or meniscus of the waterline; it may be light or dark. You can always add this later with white gouache, or lift it out with the damp tip of a brush. Note the distortion of stems below the water line. You only need to hint at these elements; the eye will do the rest.

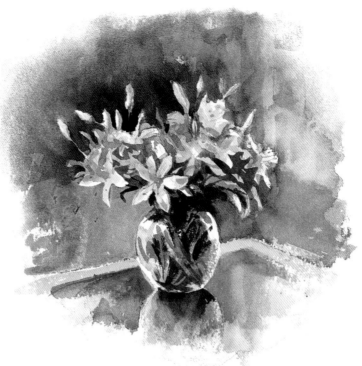

▲ *A pale blue wash is painted over the glass bowl, but the highlights are left as white paper. Dry-brushwork makes a broken reflection on the right-hand side.*

The reflective surface

When the painting is dry enhance the reflective nature of the glass with pale transparent washes of blues, greys or white paint applied with a wide flat brush directionally over the surface.

Dry-brushing with neat white gouache is another way to add highlights to reflections.

Adding accessories

If the composition looks empty or boring add some interesting visual accessories. Books, whether open or piled, look great beside a vase of flowers, as do hats, lacy or patterned cloths, cups and saucers, fruit, bottles of wine; in fact, any note of human interest. This juxtaposition immediately tells a story to the viewer by indicating a human activity has taken or is taking place.

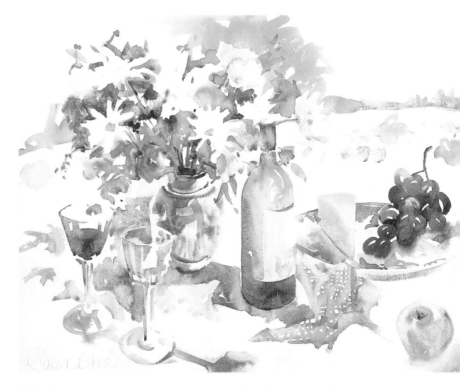

Picnic
54 x 76 cm (21 x 30 in)
Sarah Bibra
Some of the best compositions are accidental, rather than arranged. Look out for these around you. They bear the stamp of spontaneity that is hard to simulate and never look quite as good when you try to rearrange them.

project

Playing with Light

Once you achieve a measure of success in your watercolours it is important to avoid becoming too 'precious' in your attitude to painting. The aim of this project is to paint the flowers, still life and background fairly fast without undue attention to detail, to concentrate on the effect of the light on the flowers and then to use dry media (crayons and conté) to emphasize the play of light. In other words you are going to cover up some of your 'precious' watercolour with other materials. Coloured crayons are an ideal complement to watercolour. They can be easily rubbed off, so you can change your mind, and they retain luminosity when laid over watercolour. Using black conté gives you the chance to strengthen dark areas of the painting with brisk energetic strokes, bringing out the radiance of the untouched watercolour washes.

Position your vase of flowers by the window. For the sake of variety choose three different containers with very different flowers in each. Gather one or two still-life items to vary the composition in each painting.

Colours: your usual selection, plus white gouache

Paper: 300gsm/140lb Not surface watercolour paper, sheets of strong coloured or tinted paper

Equipment: Coloured crayons and black conté pencil, flowers in a vase

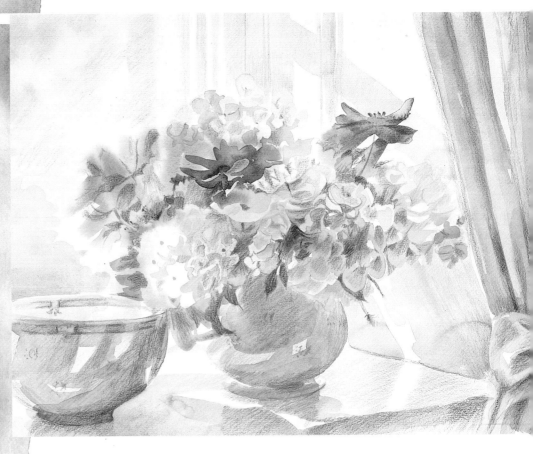

The Shaft of Light
40 x 50 cm (16 x 20 in)
The shaft of sunlight streaming through the window bathed the colours in an ethereal light. I painted the flowers with loose pale washes, leaving the lit blooms as white paper. The shadows were painted in mauve washes. The painting looked vague and formless, but the quality of light was there. With the coloured crayons I drew in some details on the flowers, and with a violet crayon strengthened the shadows on the bowls, windowsill and curtain.

76

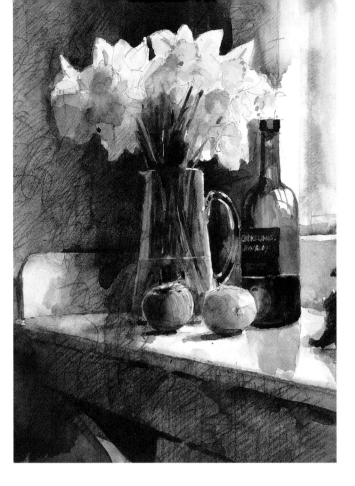

Still Life with Daffodils
41 x 29 cm (16 x 11¹/₂ in)
John Lidzey

Bold yellow washes are painted over the flowers, jug and background. Apart from the light of the window and the light cast on the sill, the rest of the painting is darker than the flowers. A black conté crayon is effectively scribbled over the dark washes. The stark contrast makes the daffodils look both radiant and delicate. See how free you can be with your pencil strokes and yet be in control.

Lastly, try using coloured paper. Painting on a tinted ground takes away the need to think about background tone, and enables you to concentrate on the variation of light and dark across the flowers themselves. As you have to create the highlights with white paint rather than white paper you will be far more aware of where they appear.

Hamble River Blues
50 x 70 cm (20 x 28 in)

I chose to work on blue paper to bring out the tones of the pink wisteria. The colour of the flowers changed from almost white, through pink by the window to a dark crimson on the shaded side. Since I had to mix varying amounts of Alizarin Crimson with white gouache I became very aware of the different tones of pink on each flower. I used black conté for the darkest darks, and found I needed very little detail on the blue paper to suggest the river through the window.

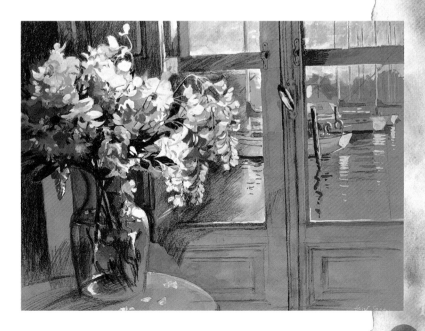

gardens of eden

The word 'garden' sums up a **delightful, pleasurable, peaceful** and private place. For **artists** who hate being watched **the garden** is a **haven** for painting **outside**. It is **immensely fulfilling** to work outdoors. Maybe it is the awareness of the slightest changes in **weather, wind** or **sky**, or perhaps it is simply the proximity to **beautiful** growing things.

Even if you have no **garden** of your own in which **to paint**, most towns have **public gardens**, often kept to a very high standard, and many cities have **botanical gardens** that offer a wealth of **fascinating species** to paint.

chapter ten

OVERWHELMING COLOUR

The order imposed on **nature** in a garden provides **the painter** with an **abundance of blooms, great colour** combinations and **interesting compositions** where man-made structures interact with **organic shapes**.

You may choose a **wide view** of the garden, **banks of flowers** receding into the distance, or a **floral border** to a path. Alternatively you may wish to **focus** on a few **blooms** in their **natural setting**, to come in close using the **foliage** as a backdrop. Also consider the untidy, **overgrown corners** where odd items are discarded; small corners can be more **evocative** than the larger view.

The Perfect Summer
40 x 30 cm (16 x12 in)

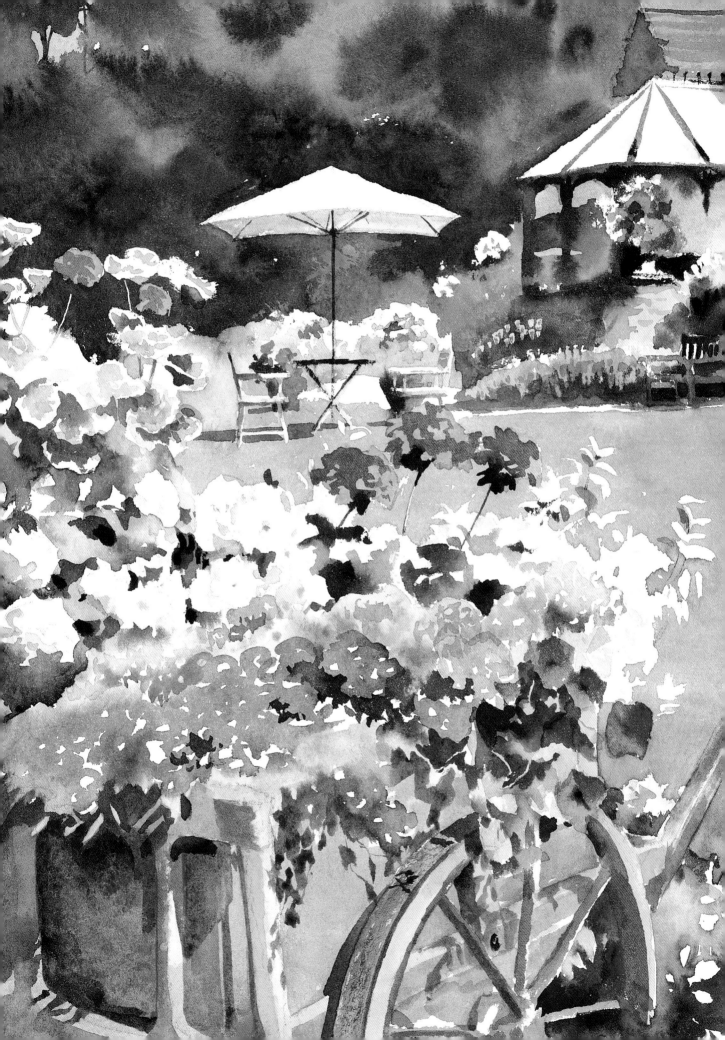

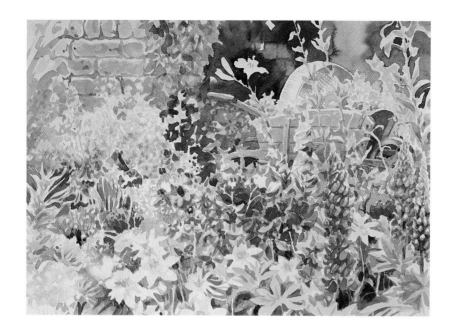

Fragment of a Garden
38 x 55 cm (15 x 22 in)
I wanted the painting to mirror the profusion of overgrown flowers that are half revealing, half obscuring the old wooden wheelbarrow, so I came right up close to the flowers and let them fill the foreground of the painting.

Point of view

As with every painting, the position you choose to work from is paramount to the painting's success. Be really fussy about your position and do not settle for second best. Use your viewfinder to decide the composition. Make yourself comfortable. Lay your painting equipment by you so that it is all within easy reach and preferably on the same level as your paper.

Your subject should be directly in front of you, so you only have to move your head to see your view.

practical tip

❀ Note both the lightest tone within a painting and the darkest, before you begin. The rest of the painting must then fall within this range.

Seeing the painting

Squint your eyes to see the main foliage masses before you begin to mark out your composition on the paper. From even a short distance you do not notice the individual flowers and leaves of the foliage at first glance. You only see the details as you study each part of the scene. So, start with the main areas of lightness and darkness to establish the forms of the plants, shrubs and trees.

Make a very quick wet-in-wet sketch to establish the main clumps of flowers. The petal colour is washed in first and while still damp the foliage colour dropped in at the base, so that it blooms softly upward into the first colour. Use this method for general flower masses.

Undertones

It helps the unity of the picture if you can find a colour that is common to the whole subject. Use the colour to establish a warm undertone. You might follow this with a dilute wash of Ultramarine or Prussian Blue for the main shadow areas on a sunny day.

In a close-up view of flowers you could paint the lightest petal colour under the whole painting, reserving the highlights as white paper. This wash serves to keep the greens of the surrounding foliage from becoming too bright and unites the composition from the start. Decide the green of the grass; can you mix it from a blue and yellow you are already using?

Foregrounds and backgrounds

To create a sense of depth treat the foreground of the painting to a greater degree of prominence and detail than the rest of the painting.

Dark backgrounds will bring out light foregrounds, so if your foreground colours seem weak or dull, try darkening the background against them.

To bring light filtering through the background foliage work wet-in-wet or use drops of pure water to create a mottled texture. Lift out excessive colour from a dark wash or modify a strong hue with a thin wash of white gouache.

Auntie Pam's Garden

35 x 50 cm (14 x 20 in)

Achieve dramatic perspective with large flower heads in the foreground, smaller blooms in the middle distance, and blurred colour in the background.

▲ *To create a pervading warmth, a wash of Yellow Ochre was laid over all the painting except for areas of flowers catching the sun.*

▼ *To make the foreground clumps of flowers stand out a dark background of Prussian Blue is painted behind them.*

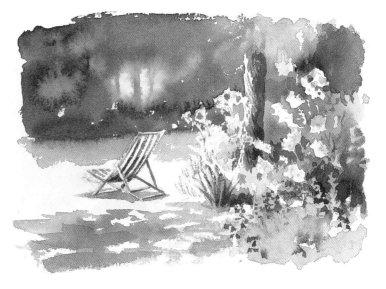

demonstration
Creating a Sense of Space

HAZEL SOAN

I wanted to find a simple composition in the garden that suggested an element of depth, a small distance between the foreground of the painting and the background. With its receding border of flowers creating a straightforward diagonal perspective line and the positioning of one clump behind the other, this floral bank offered the perfect subject.

colours

Prussian Blue
Aureolin
Alizarin Crimson
Permanent Rose

Mauve
Indian Yellow
Cadmium Red

▶ **1** I drew a light sketch on Schoellershammer 250 gsm (115 lb) paper, which has a delightful rough surface. Deciding to make my greens from Prussian Blue and Aureolin, I painted pale washes of these colours over the sky and the grass respectively. To create the sense of space I planned to make the foreground stronger and more detailed than the background.

◀ **2** I loaded a flat brush with Prussian Blue and a No 7 round brush with Aureolin so that I could quickly alternate between colours and allow them to blend wet-in-wet. I reserved the blooms and leaf blades as white paper by painting round them with the colours of the foliage and flowers.

3 I began to paint the flower clumps, from front to back, a crisp ragged edge defining the top of each clump, and soft wet-in-wet colour within each flower mass. A sense of distance began to emerge as the clumps appeared to be one behind the other, light against dark. The tree trunk was painted in one stroke. Orange colour, made from Permanent Rose and Indian Yellow, was flooded in from the base and allowed to settle.

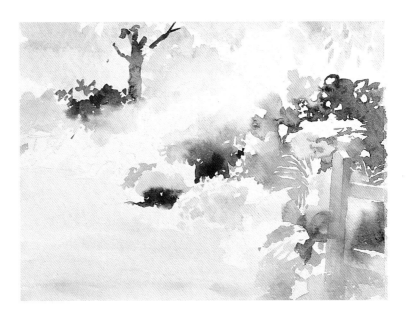

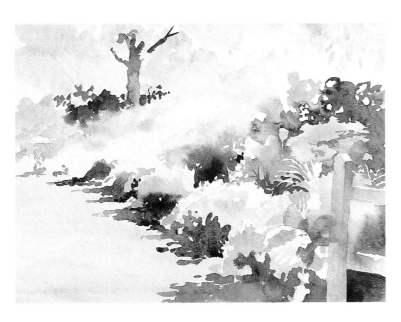

4 I laid Prussian Blue shadows out across the lawn from the clumps of flowers, continuing the blue up into the shadowy bases of the shrubs so that one grew out of the other. I wanted to lay just one wash to keep it crisp and fresh, so I mixed a fairly dense colour and went boldly in with the paint.

5 Even though I wanted the background to be softer than the foreground to create a sense of space, I felt that some details were needed to emphasize the middle distance and bring the centre of the picture to life. I painted a strong Prussian Blue over the pale Mauve wash, drawing the brush tip around the flower heads. By making them smaller than the foreground, a sense of scale was created in the picture, telling the viewer that these were further away than the foreground flowers.

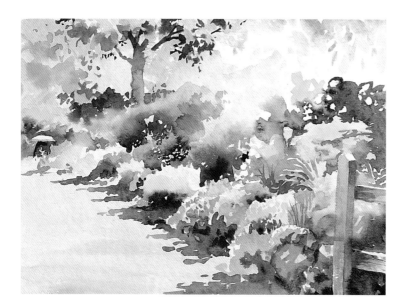

6 With a combination of wet-in-wet and small dabby washes over dry paint, I built up the foliage of the tree and the backgound flowers and shrubs. The contrast of hard and soft edges added variety to the painted surface. I continued the interplay of light against dark to bring one bush forward from another.

7 To create the wood texture of the old gate I loaded the flat brush with dry paint, splayed the hairs apart and dragged it along the length of the gate post. Darkening the gate also brought it forward and enhanced the sense of space. At this stage I painted the foliage of the small overhanging tree, dark against light.

8 I stood back from the painting and decided several of the flower clumps needed more colour, so I added various blobs of pink, red and yellow paint to the washes of the nearest clumps, leaving them paler on top where they caught the light. This also helped to suggest their three-dimensional form.

9 I lengthened the shadow cast from the small tree to break the rather regular line of shadows. Finally, I darkened the foliage on the right-hand side to bring it forward. With the strong foreground and softer background, and the diminishing scale of the flowers as they recede, I felt that I had achieved the sense of space I was looking for.

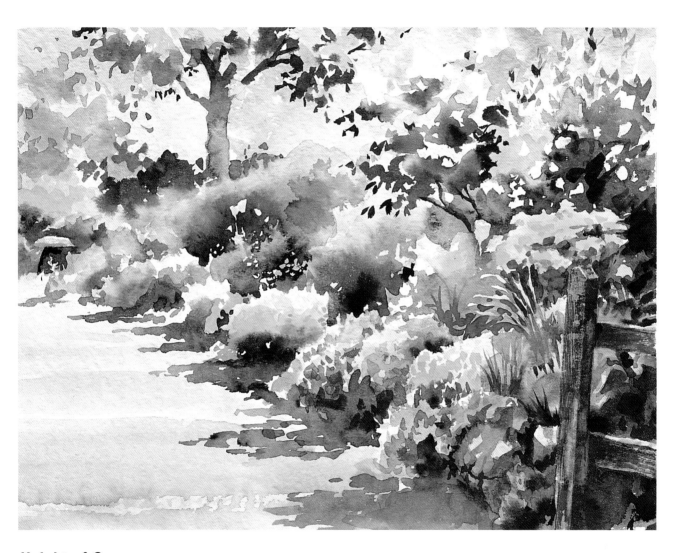

Height of Summer
30 x 40 cm (12 x 16 in)

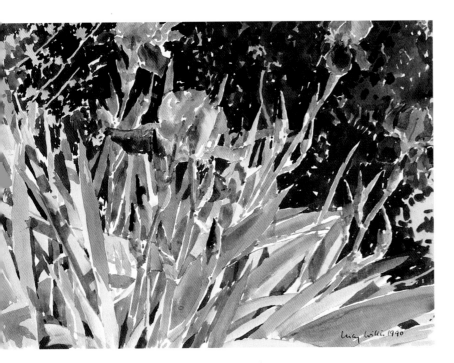

Bed of Irises
32 x43 cm (12¹/₂ x 17 in)
Lucy Willis
The artist combines a number of techniques to enliven this delightful study of irises: flat washes for the leaves, built up in a variety of tones to create order among the intertwining fronds; wet-in-wet washes for the flowers, again with an emphasis on tonal contrast; and a broken wash for the background, leaving flecks of white paper to shimmer through the rich dark colour which so perfectly brings out the flowers in front.

Techniques for flowers

There are many ways to pick out the flowers in a garden setting, and in any one painting you will probably combine several techniques.

You could reserve white paper for the flower heads and then touch their colours in when the foliage is painted. Remember you have several techniques at your disposal: reserving white paper, lifting out, and masking.

Alternatively you could wash in the flowers and their foliage in the petal colour and paint the darker foliage around the flowers, leaving the flower heads as the lighter underwash colour.

To suggest flickering sunlight break the wash with flecks of white paper.

Scatter shrubs with flowers by dabbing or dropping the flower colour wet-in-wet into the damp foliage wash.

Riverside
55 x 75 cm (22 x 30 in)
Alternating techniques of wet-in-wet and wet-on-dry brush strokes play across this vivid painting. Masking fluid has been applied to reserve the red and pink flowers in the planter from the background; likewise the individual yellow irises.

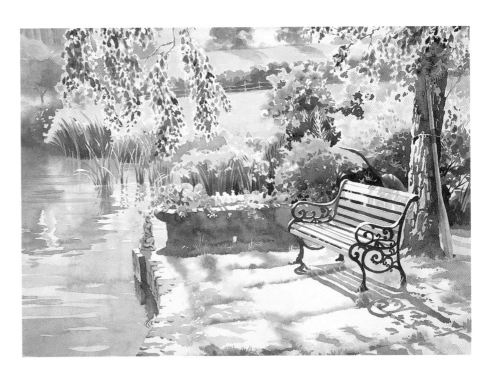

Variety or confusion

Garden paintings can become confusing if too much is going on in the scene. Variety does not mean including dozens of different species and colours; it means variety of colour, brush stroke, tone, shape and detail.

Contrast areas of activity with areas of rest such as lawns and simple backgrounds. You are under no obligation to paint every bud and bloom of the plants in front of you, and in fact the opposite is true – you must distil them down to their essence. Most said with minimum means should be the watercolourist's motto.

Trees

The strong vertical and diagonal lines made by the trunks and branches of trees are a wonderful compositional contrast to soft floral masses. In most garden scenes it is unlikely you will see more than the lower part of the tree, unless the trees are in the distance. Try not to make them too rigid. Show a contrast from light to dark across the trunk. If it is entirely in shadow do not be afraid to paint it really dark. Tree trunks are rarely brown; they can be greens, greys and purples. You will be surprised how much colour is in them and how dark they can be.

Lights on leaves

Highlight leaves by painting the background around them, or retrieve them at the end of the painting by using opaque colours. Lemon Yellow is marvellous for painting light leaves over dark washes of colour.

▶ *Use the end of a flat brush to paint the limbs and trunks of trees. The fine tracery of branches can be painted with a rigger, and light foliage applied with a sponge.*

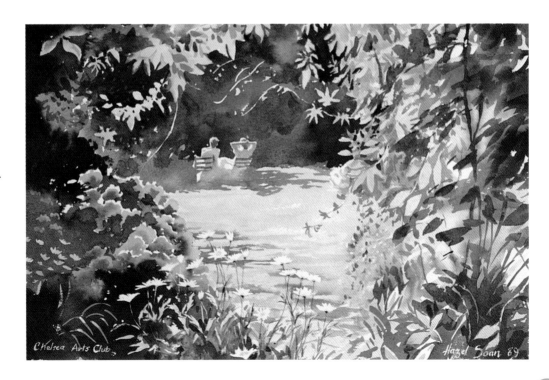

Lunch at the Arts Club
55 x 75 cm
(22 x 30 in)
Most of this painting is green, but the variety of yellow and blue greens that dance around the perimeter of the painting, and the different techniques used to attract attention to specific leaves, create the interest.

project

Colours: Full selection

Paper: Not surface, heavy as possible

Size: 38 x 55 cm (15 x 22 in)

Equipment: Masking fluid

Experimenting with Techniques

The aim of this project is to show you how to experiment with different techniques to create the effect of flowers in a garden setting. Each method available to the watercolourist creates a different finished 'look'. The techniques I want you to try are: reserving white paper, using an underwash of petal colour, and reserving with masking fluid.

Underwashing with the petal colour creates an instant unity as the flowers and foliage are bound together by the underlying colour. Soft blooms are created if you add the foliage washes while the flower wash is slightly damp, so prepare your colours in the palette first. Experiment with small and large areas, close-ups and distant shrubs.

Henley Backwater
50 x 38 cm (20 x 15 in)
Reserving white paper:
In order to leave convincing shapes and areas of white paper for the flowers and highlights I drew a guiding sketch for the brush. The dark water area by the boathouse door required specific attention to reserve the flowers and leaves popping up above the brick wall. I then painted up to and around the flowers I wanted to leave as white paper or paint pink. The leafy reflection in the water was painted quickly with wet-in-wet washes and leaf-shaped brush strokes.

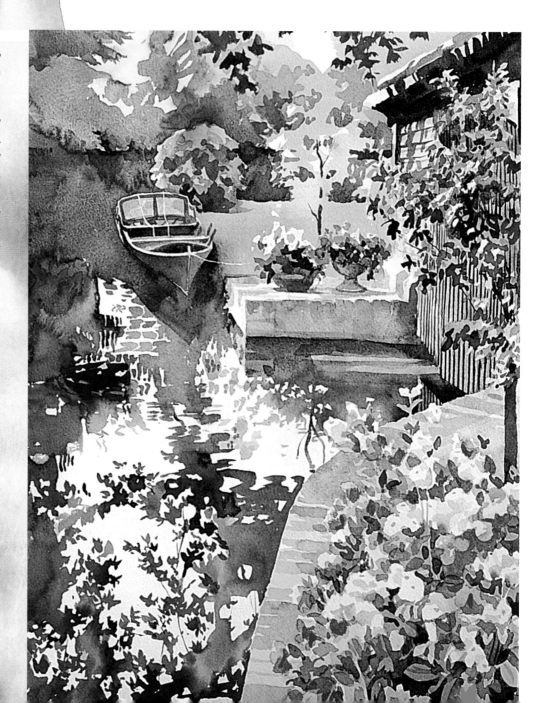

Underwash of petal colour: *I washed a mixture of Indian Yellow and Permanent Rose over the rose bush. Just before the wash dried, I painted round the rose shapes with Sap Green and Prussian Blue; the edges of the outer petals were soft and 'fuzzy' where the orange wash was still slightly damp. Interior details of the roses and darker foliage were added when the paint was dry.*

self-assessment

❀ Did you prepare for the technique you were using?

❀ Does the technique chosen successfully evoke the blooms painted?

❀ Was any one technique more enjoyable to use than the others?

❀ Do you find one effect more preferable in appearance?

Contrast the marks made by masking out flowers with the shapes created by reserving them as white paper. In general the reserved shapes have a fresher, less blobby appearance than shapes made with painted masking fluid as the surrounding brush stroke allows more spontaneity. However, if by masking you are able to lay your washes with freedom and you take care to paint the masked-out flowers and leaves in specific rather than general shapes, you will find the effect satisfactory and very useful for garden landscapes. To protect your brush from damage by dried masking fluid when you are working outside (without access to warm soapy water), gently rub the hairs with vaseline before dipping the brush in the fluid.

Lazy Summer Days
38 x 55 cm (15 x 22 in)
Masking: *All the flowers and leaves in the foreground, the highlights of foliage on the right, and the hammock slung between the trees were masked out before painting began. More attention was paid to making specific leaf and stem shapes than to the flowers as these were to be painted over with crimson washes. By protecting the foreground with masking I could freely wash in the lawn and my chief interest – the dynamic shadow from the trees.*

89

Patios and pots

There is something **intrinsically cheerful** about **flowers in pots** as they **cascade** from window sills, **parade** around patios and **march** down steps. The care that goes into growing them is rewarded with **breathtaking displays** of colour that **brighten any corner**.

The **contrasts** of shape between the solid **pots** and the **overflowing flowers** make exciting compositions for the flower painter. The rich oranges and red-browns of **terracotta** start the painting off on a **vibrant note** even before the addition of full floral **colour**, and the **lights and shadows** cast by one pot against another create interesting **patterns** of tone.

chapter eleven

AN EXTRA DIMENSION

In one way these paintings are **garden still lifes**, and much of the information in chapters 9 and 10 applies directly to these. However, as **most patios** and **courtyards** are paved with rectangular **stones**, and bordered by steps and **walls**, perspective is a more obvious element. The **criss-cross** of parallel **lines** gives the beginner great opportunities to learn **perspective** in an almost intuitive way.

If your only opportunity to **paint** is **on holiday**, here is a subject made for you. **All over the world** hotels **adorn** their premises with **living colour**, a **paradise** of terracotta pots and **flowered** balconies.

Sociable Pots
53 x 43 cm (21 x 17 in)

Understanding perspective

Perspective is less daunting to tackle than many people suppose. Your eye-level is the key. Hold your hand horizontally across the bridge of your nose. Push it out level away from you. This is your eye-level, the horizon. Mark on your painting (use your viewfinder to help you) where this line crosses the paper. If you are looking slightly down on your subject, as you may well do for a group of pots, the eye-level will be higher up the page than if you were looking straight across. It might even be above the page; in that case mark it on your drawing board to help you.

All lines below the eye-level that run away from you go up to the eye-level (for example, paving stones). Lines running away from you above your eye-level go down to the eye-level (for example the tops of walls and windows). If the lines are parallel in the 'real world' they will appear to converge as they run away from you and meet at a common vanishing point on the horizon.

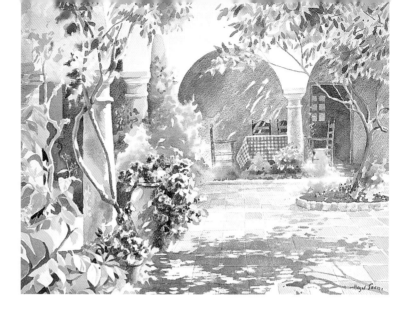

Almoraima
45 x 60 cm (18 x 24 in)
One vanishing point: *If one line of the paving runs parallel to the horizon (eye-level) the parallel lines of paving running into the distance will all meet at one vanishing point on the horizon. The columns run parallel to the paving, so they share the same point.*

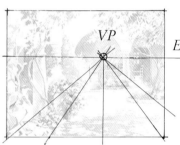

EL: Eye-level
VP: Vanishing point

Private Enclave
38 x 49 cm (15 x 19 in)
Two or more vanishing points: *Both lines of the paving run at an angle to the horizon, thus creating two vanishing points, one of them way off the paper. The* garden wall runs parallel to one line of paving and therefore meets at the same vanishing point, but the conservatory wall takes a completely different angle and so creates a third vanishing point.

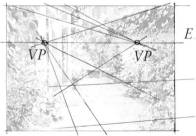

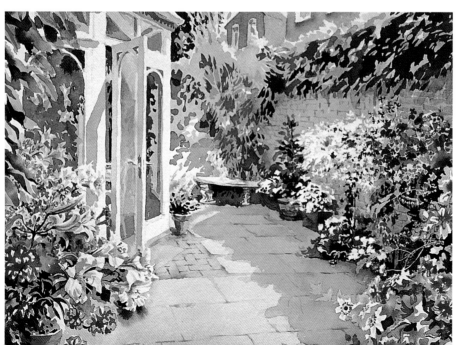

Shapes, not blobs

There is a tendency among beginners to paint their flowers as a mixture of nebulous blobs of petal and leaf colour. Think instead in terms of shapes, however small, and be specific. These suggest the flowers interspersed among the foliage much better than random blobs made with the tip of the brush.

You can either paint the foliage as a wash, leaving white spaces for the blooms, or paint the blooms first and paint the foliage around them. Rather than try to paint every separate bloom, see them in groups of overlapping flower heads. Pick out individual flowers within the groups by strengthening the colour of some petals and leaving others pale. Again try to emulate the shapes the dark petals fall into rather than using indiscriminate blobs.

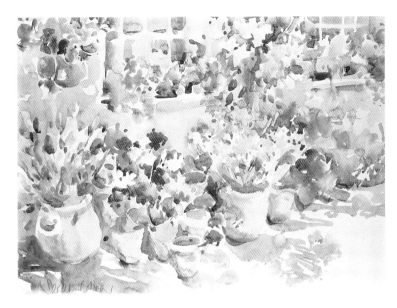

Terracotta Flower Pots
54 x 76 cm (21 x 30 in)
Sarah Bibra
Even though the flowers are painted loosely the shapes are specifically different, enabling the viewer to guess immediately which flowers they represent. Likewise the foliage areas carefully alternate between specific and vague shapes.

Highlights and main contrasts

Do not be afraid to leave the lightest flowers or petals as white paper. Even though a group of blooms may be red, where they are lit with bright sunlight the colour is bleached out. You can always touch them in with some colour later if the white is too dazzling or bland.

Between the flowers and leaves brimming from the pot will be a myriad of dark tones. Including too many of these may detract from the overall light and shade of the floral mass, making the painting look fussy. Just paint the main contrasts, and leave the rest to the imagination of the viewer. Bring out the colour of any 'lost' flowers by darkening the foliage between them.

To establish the flower arrangement against the shadowy background between the columns it was necessary to make the underside of the hanging basket very dark indeed. At the top opaque Lemon Yellow was used to paint a few loose blooms against the dark background.

demonstration
Painting Sunlight and Shadows

HAZEL SOAN

Mediterranean courtyards are bubbling with colour and bathed in strong sunlight. The shadows cast are well defined and form an integral part of the picture, if not the very reason for painting it. I sought a small corner of a courtyard full of flowers to experiment with the contrast of light and shade.

colours

Ultramarine Blue Mauve
Permanent Rose Cadmium Red
Sap Green Burnt Sienna
Cadmium Yellow

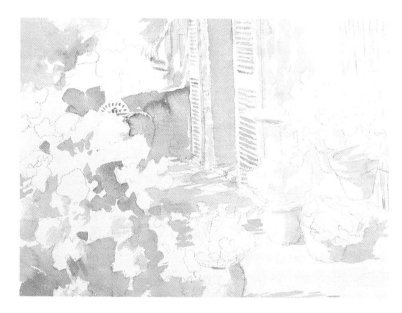

▶ **1** I drew the composition fairly carefully to establish the position of the shadows and lights. I used a heavy 640 gsm (300 lb) Saunders Waterford paper that did not need to be stretched. With a size 10 sable brush I painted all the areas that were bathed in shadow with a wash of Ultramarine. I reviewed the composition to check there was a balance between the light and dark areas.

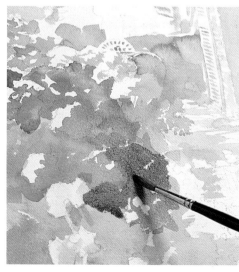

▶ **2** With a size 7 round brush and alternating washes of Permanent Rose and Sap Green I began to create the pattern of flowers and foliage among the geraniums on the left. I left highlights as white paper and let the bottom edges of the flowers run into the Sap Green wet-in-wet.

3 I laid a pale wash of Cadmium Yellow and Permanent Rose over the wall, paving and background to enhance the warmth of the sunlit surfaces. I then touched in pale washes of Permanent Rose, Sap Green and Cadmium Yellow for the flowers in the pots.

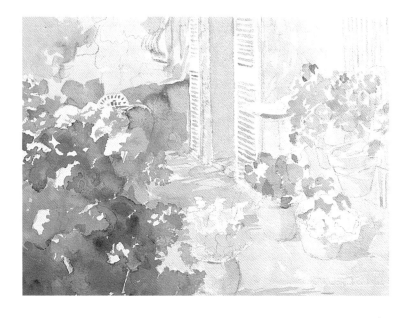

4 I painted the terracotta pots with pale mixtures of yellow and red, and Burnt Sienna. While still wet I touched in the darkness between the pots with strong Burnt Sienna, letting the colour flood out at will.

5 To bring out the left-hand geraniums I now darkened the background trees with a mixture of Sap Green and Mauve. I also darkened the area behind the chairs with a Mauve wash. I strengthened the pots and laid small patches of Burnt Sienna for the earth inside them.

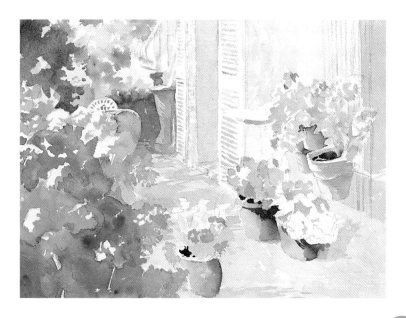

▶ **6** Having laid a general wash of colour over all the elements of the painting, I began to work on each part to bring it to completion. I started with the large geranium bush, alternating between strong washes of Permanent Rose and deep, dark washes of varying mixtures of Sap Green and Mauve. I kept the tops of the blooms crisp edged, and let the undersides blend wet-in-wet into the foliage. I painted round a few leaf and stem shapes, letting the colour of the underlying wash come through.

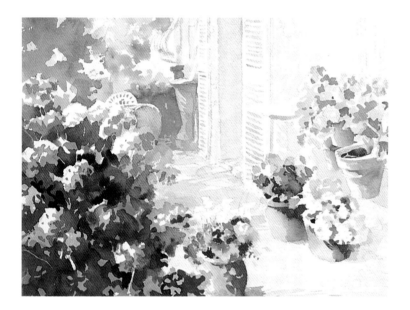

◀ **7** I now built up the flowers in the pots. The white flowers were described by painting round their shapes with Sap Green, varying the tones of the green. Darker greens were added to the leaves of the pink geraniums to suggest that one group of leaves lay behind another. I let the flower colours of the foreground pot run into each other and painted in the shadows cast by the blooms.

▶ **8** With the side of a flat brush I painted in the window bars. I mixed a grey from a combination of colours in the palette: Mauve, Sap Green, Ultramarine, and a touch of yellow and red. When the first tone had dried I painted another line of the same colour grey down one side of the bar to create its three-dimensional form. I brought the dark of the bars firmly up against the light tops of the flowers to bring them out from the background.

9 I mixed more of my grey mixture, adding extra Ultramarine for the interior dark of the doorway and shutters. Then I brought out the shapes of the white flowers in the central pot by painting round them with the shadow colour, slightly diluted and with a touch more Mauve added.

10 I strengthened the trees in the background to push forward the geraniums and added linear brush strokes of pale orange to give form to the paving stones. The warmth of both the lights and darks lent heat to this intimate scene.

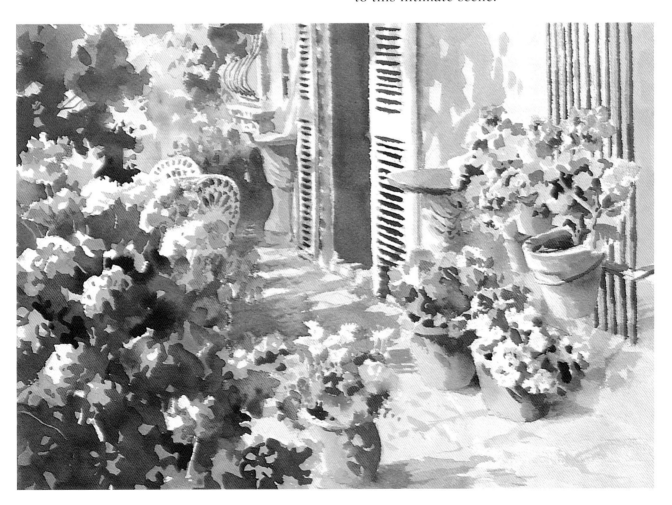

Sunlight and Shadows
50 x 70 cm (20 x 28 in)

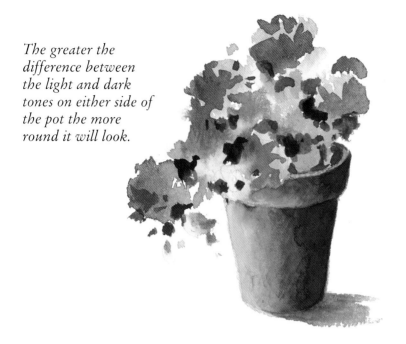

The greater the difference between the light and dark tones on either side of the pot the more round it will look.

Round pots

On a sunny day the lit and shaded sides of a pot and the flower mass on top are self evident, but half closing your eyes will help you see the main tones more clearly. To make your pots look round darken one side of the pot and leave the other one light. Remember to bring dark up against light and light against dark in the background. Use this contrast of tone to emphasize one pot of flowers behind the other.

On an overcast day these contrasts are not so obvious, but they are still there in subtle form.

Colour variations

Even if terracotta pots are the same colour a little variation within the mixture, and within each pot, adds character and prevents monotony. Paint a wash of Yellow Ochre or Orange before plunging Burnt Sienna or a mixed red-brown into the damp wash. The variation in colour suggests reflected light from the flowers, patio or other pots.

Forget using greys to darken the sides of the pots, and boldly choose richer browns, blues and mauves, even dark reds. Try to lay the right tone with your first wash to keep crispness and spontaneity.

The Blue Blind
75 x 55 cm (30 x 22 in)
This balcony scene is enhanced by the variety of colours and tones used for the terracotta pots. Even the shaded pot bottoms are painted with varying tones, sometimes darker, sometimes lighter than the rest of the pot.

Shadows

Shadows on and from pots are a joy to paint. However, shadows will appear to move quicker in relation to these smaller objects than in a garden view, and you may have to work fairly fast if your subject is lit by strong sunlight. Avoid changing your picture to keep up with the moving shadows, but refer to your first sketch and paint all your shadows as if they had the same source of light.

Wall and paving textures

Placing flowers in the company of brickwork and stone creates a great contrast of texture. Wax drawn over the stones and then overlaid with another wash brings out lovely mottled textures. Dabbing paint with a natural sponge makes a fine patina. Or you could experiment with spatter.

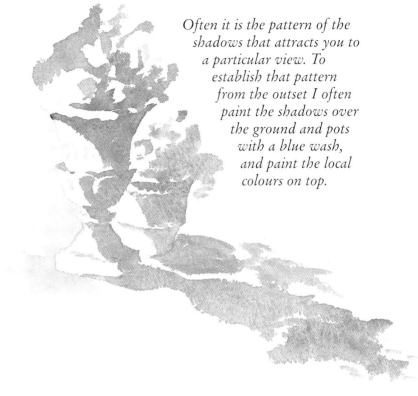

Often it is the pattern of the shadows that attracts you to a particular view. To establish that pattern from the outset I often paint the shadows over the ground and pots with a blue wash, and paint the local colours on top.

Delicate brickwork can also be painted with the end of a flat brush. Here the width of the brush determines the size of the bricks. The tone varies as the brush yields up its load. A flat brush is also great for creating the crisp straight lines required for garden furniture.

Use the tip of a wax candle to draw the mortar lines of a brick wall, and then freely paint a wash over the top. The result is more convincing than painting every brick, and you can vary the colour in the wash too. Note also the use of overlapping objects to create depth and the use of light against dark at the sides of the pots.

project

Colours: Permanent Rose, Cadmium Red, Cadmium Yellow, Sap Green, Viridian, Mauve, Prussian Blue, Ultramarine Blue

Paper: Langton sketchbook 300gsm/140lb Not surface

Size: 25 x 35 cm (10 x 14 in) or smaller

Time: One hour each sketch

Equipment: Viewfinder, ruler

One-point perspective: *Try to assess the perspective lines visually. I chose to look straight into the sunlight for this sketch. The shadows therefore fall to either side of the centre line and add to the sense of perspective already created by the flagstones and the diminishing size of the pots. When you have finished run a ruler along each line to see if they all converge at one point.*

Practising Perspective

Start by finding your eye-level by placing the side of your hand or sketchbook across the bridge of your nose. First look down on a one-point perspective view; that is, where one line of the paving runs parallel to you and the other lines head off to one vanishing point at your eye-level (which will be above or at the top of the painting in this case). Try the first sketch without any ruled lines and see how accurately you naturally assess perspective without actually measuring.

Do not try to finish the whole painting; these are sketches purely for the purpose of practising perspective. Include two or three pots of flowers and concentrate on their relative sizes as they recede.

For the second sketch seat yourself at an angle, so that you have two vanishing points for the paving, and maybe some steps. This time draw in the eye-level and perspective lines and paint over the top.

For your third sketch choose a composition with your eye-level in the centre, where lines come down to, as well as go up to, your eye-level. This could include arches and

Two-point perspective: *This time draw in your eye-level. Now pick one line of the steps or paving and continue it to the eye-level. That will be the vanishing point. Now all other parallel lines have to converge at that point for the perspective to be correct. My second vanishing point was too far off the page, so I continued the lines a little and checked that each line slightly converged with its neighbour as if going to a common point.*

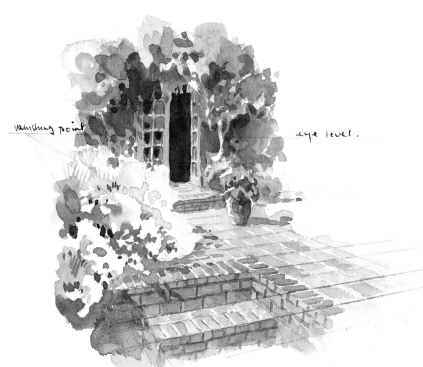

colonnades, high walls or conservatory eaves. This is easier to accomplish with one vanishing point, so check that one of the structural lines runs parallel to you.

I have deliberately darkened the perspective lines so that you can see my working out, but in practice, even though the lines were clearly drawn, they actually disappeared under the watercolour.

self-assessment

❀ Did you note or draw in your eye-level?

❀ Do all parallel lines converge at the same vanishing point?

❀ Were you aware of the relative sizes of the pots?

❀ How accurate was your visual assessment of perspective; have you checked the lines with a ruler?

Up and down to the eye-level: *My eye-level crossed the centre of the sketch. I checked the side of the building ran parallel to me so I only had one vanishing point to worry about. I chose the line along the bases of the columns as my first line, continued it to the eye-level, and marked the vanishing point. All I had to do then was fan out the lines from the one point and the perspective fell into place. Follow the lines of the architecture back to the vanishing point on my sketch.*

101

going Wild

What could be more **pleasurable** than being out in the **countryside** under the **open sky**, painting **wild flowers**? You become so **sensitive** to your surroundings that you notice the slightest change in the **breeze** or rustle in the **grass**. Yet you are so **absorbed** in the painting that you are unaware of feeling cold, hot, tired or hungry. I can think of nothing more **flattering** than when an insect chooses to investigate the **flowers** I have **painted** rather than the **real ones** in front of me.

chapter twelve

FLOWERS IN THE LANDSCAPE

Wild flowers can be found growing anywhere; on the slopes of **mountains**, on the **shores of seas**, along the **highways** and **byways**. It is not only the open countryside that makes the **paintbrush quiver**. A **splash of colour** in an urban street where **flowers** have pushed their way through concrete is also **fun to paint**.

There is a sense of **freedom** in painting **wild flowers** that allows the artist to be more **expressive** and less **controlled** than in the subject matter we have looked at in previous chapters. Here is a chance to **throw caution** to the wind, to **experiment boldly** with **wet-in-wet**. Simply allow the **happy accidents** of watercolour to excel themselves, and **indulge** in **exciting** textural techniques.

Primroses
38 x 28 cm (15 x 11 in)
Ann Blockley

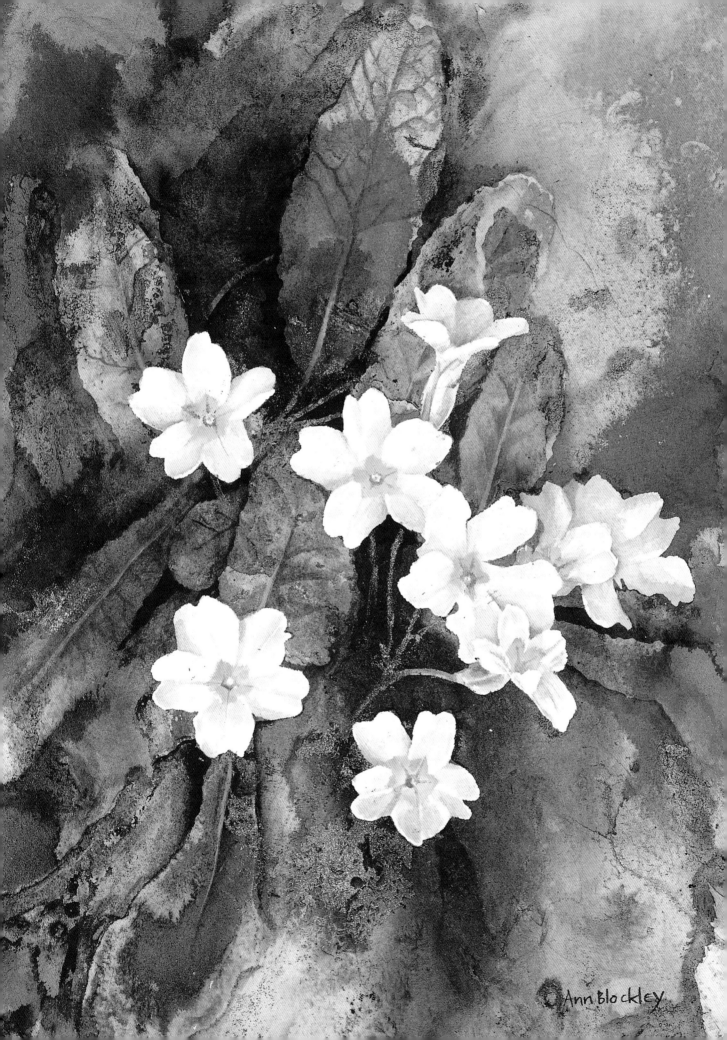

Ann blockley

Composition

Coming up close to paint wild flowers you enter a world of generous abandon. Blooms burst out in full array, leaves overlap and stems intertwine. Sometimes all this works as a ready-made composition, but at other times the flowers look great but the background looks a muddle. Before you plunge in, take time to plan the composition. Remember that you are the boss and the view in front of you is not sacrosanct. In a few hours your painting will have to stand alone, unaccompanied by its inspiration.

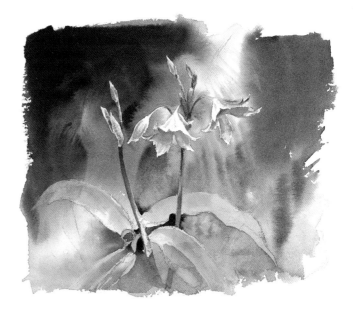

Hidden Jewel
38 x 55 cm (15 x 22 in)
In this painting of a wild amaryllis the complicated background of lush undergrowth is simplified completely with a wet-in-wet variegated wash.

Wild Flower Patch
28 x 38 cm (11 x 15 in)
Alan Oliver
Many exciting textural effects have been used to create this dynamic painting, but it is actually the composition and arrangement of the group of white daisies that make it so successful. We enter the painting through the focal group of white flowers and then are led up and away into the vibrant background of trees by the three upturned blooms at the top of the meadow.

Groups of flowers

Look for blooms that together form an interesting shape. Perhaps make one group the main feature and use other flowers to balance the composition. Include buds and half-open blooms to create variety. Make sure some overlap each other and are partially hidden behind the foreground flowers to give depth to the arrangement. Choose an angle that avoids too many flowers viewed at full face; a variety of angles is more interesting.

Flowers in the foreground

If the flowers are the foreground of a view, do not be afraid to bring them right up to the front, even make them quite large. Smaller flowers behind immediately create an impression of depth. Avoid making those dotty blobs that are intended to be shorthand for a mass of blooms.

Changing eye-level

A lower viewpoint might help make the composition more dynamic. Sit on the ground so that the foreground flowers rise higher in the picture plane and cross your eye-level. You can then paint these in detail and let a wash of colour hint at the flowers behind.

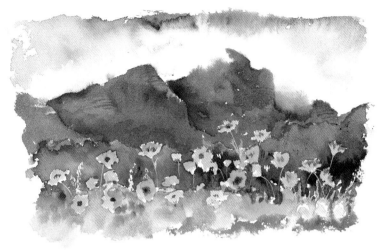

By sitting down on the ground you lower your eye-level and thereby raise the flowers above the horizon level of your picture, giving them prominence in your composition.

exercise

✿ Make three colour sketches of the same group of tall flowers – one from a standing position, one from a seat, and one from sitting on the ground. Note how the flowers rise higher on the page as you sit lower.

Carpets of flowers

Squint your eyes to see the extent of colour and any areas of darker tones. A general approximation is more likely to look convincing than attention to specific details within the mass. However, where they come into the foreground, beneath the viewer's feet, there you can identify the individual blooms that make up the display. Perhaps make these lighter in colour than the background flowers to bring them forward.

Where the colour meets the horizon create a light soft edge with broken or lifted-out colour to suggest the light shimmering on the flowers. Choose a sky colour that enhances the flowers, perhaps veering towards the complementary of the flower colour.

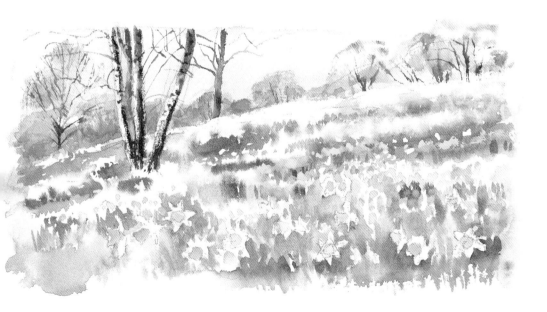

In this sketch of daffodils depth is created by giving the foreground blooms prominence, while washes of colour indicate distant banks of flowers. A mauve sky brings out the yellow of the daffodils.

demonstration
Making Different Marks and Edges

<div align="right">

ANN BLOCKLEY

</div>

My interest in this corner of a poppy field was the pattern of vibrant scarlet patches embroidered into the intricate design of swaying grasses and stems. I wanted to create a variety of marks, lines, edges and shapes that suggested or described the meadow flowers and foliage by playing with paint and ink and exploring their tactile qualities.

colours

French Ultramarine	Permanent Sepia
Quinacridone Gold	acrylic ink
Green Gold	Permanent Flame
Cadmium Red	Red acrylic ink

▶ **1** I decided to use a variety of techniques that are mainly to do with hard and soft values. I am particularly interested in the edge qualities that result from using the washing-out process with a combination of watercolour and ink whose drying times and staining power differ. To start the painting I drew the outlines of the main features, but only masked the most prominent poppy, seedheads and leaves, then left it to dry.

▶ **2** I applied a variety of wet-in-wet washes with variations of French Ultramarine, Quinacridone Gold and Green Gold. Cadmium Red was also washed into the areas of the background poppies. I dripped rich-coloured Sepia and Flame Red ink into the watercolour, encouraging dribbles. This left hard-edged areas of white which would have different edge values later.

Most of the marks and textures were placed in the foreground to bring it forward, whereas the top part of the picture was left to recede softly into the background.

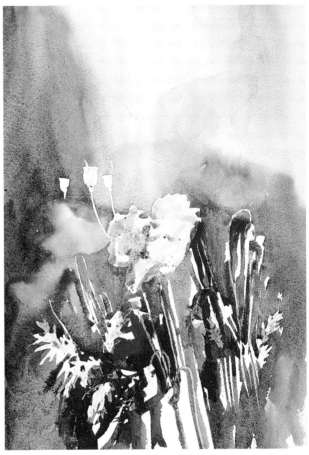

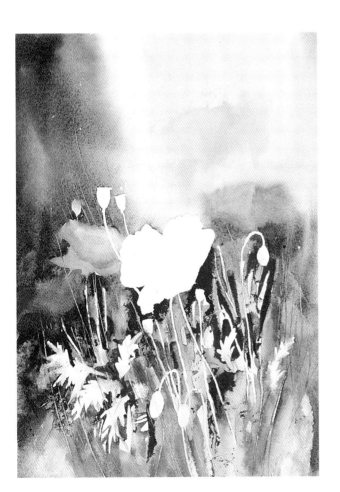

◀ **3** I then washed-out parts of the painting. I waited a minute or so until the paint was still wet in places but dry or only damp in others. The timing is crucial – over-dry paint may not want to leave the paper at all, but if you wash out too soon it may all disappear! The drying ink clings at the driest edges, creating hard lines and also granulates as it mixes with the water. The result is hard and soft edges, crisp patches and elusive feathery shapes.

Working quickly with sweeping downward movements, I used a scalpel point to scratch out stems. When the paint was dry I peeled off the masking fluid.

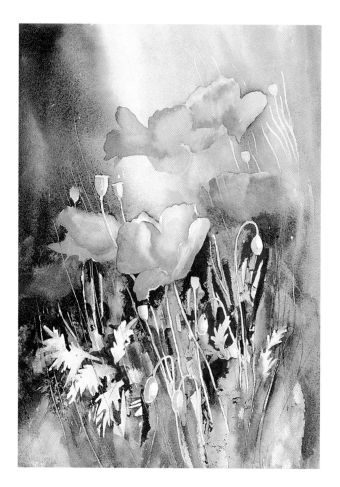

◀ **4** I painted washes of Cadmium Red into the white paper of the main poppy and also to begin forming the poppies at the top. With the diluted colours used for painting the background I washed over the white stems and leaves to tint them. I also painted more colour into the top right-hand corner around the partly formed poppy and stems.

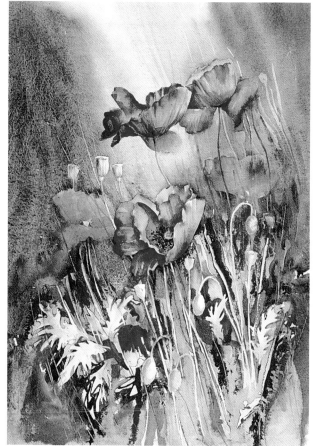

▶ **5** I continued to work more detail into the poppies. I used some red ink for a stronger colour and 'explained' the petals with layers of paint. I put in the details of the centre and stamens of the main flower head with sepia ink. I developed the negative shapes between the leaves and stems.

▼ **6** I added more detail, such as the fine delicate hairs on stems and buds. However, I was careful not to overwork the painting, leaving the white shapes to offset the surrounding colour.

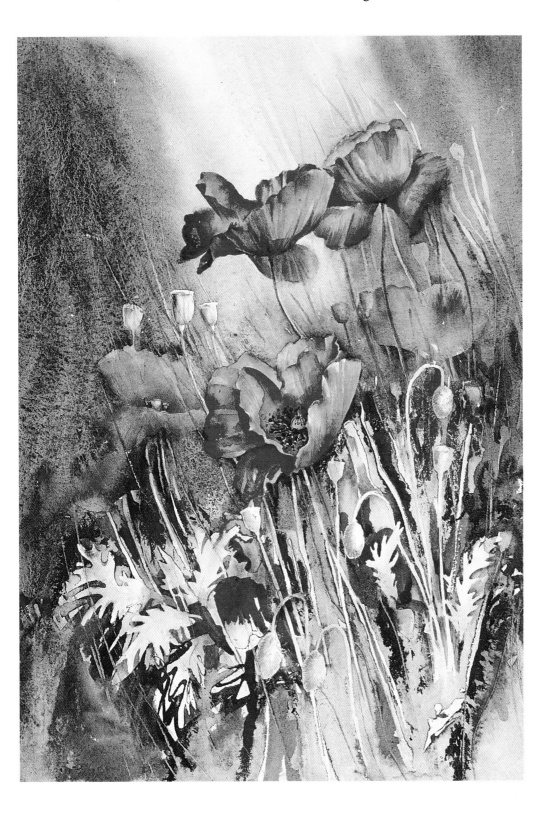

Poppy Field
38 x 28 cm
(15 x 11 in)
Ann Blockley

Trees

Where trees rise up from among flowers try to avoid painting solid trunks. Break them up with the interruption of flowers or foliage and allow leaves to cross in front. You could use dry-brush strokes or sponging, or leave flecks of white paper between the dark tones of the base of the tree trunk and touch these in with flower and leaf colour later.

The appearance of distant trees can be suggested with transparent overlapping washes, dry-brush or sponging. Light trunks can be described by reserving them from successive washes.

Leaves and branches

Remember to look for the general darks and lights among the trees; forget the tones of individual leaves. A rigger with its fine line is ideal for thin branches seen between foliage. Touch these in while the foliage masses are still wet, and do not be afraid to use the same colour as the foliage or a darker version.

Close-ups of bark are always intriguing. Play with the textural ideas mentioned in Chapter 3.

Leafy backgrounds

Simplify a complicated background into a variegated wash of colour, an interchange of lights and darks hinting at the foliage behind. You can drop clean water into a wash to create soft areas of light.

Painting leaves is as interesting as painting flowers, but paint too many and the picture may look cluttered. Generalize or look for a group of leaves that work well

Spring Quakies (detail)
James Harvey Taylor
By breaking up the base of the tree trunks with flecks of white paper and criss-crossing the lower trunk with speckles of foliage, the graceful silver birches truly rise from amidst the pink flowers.

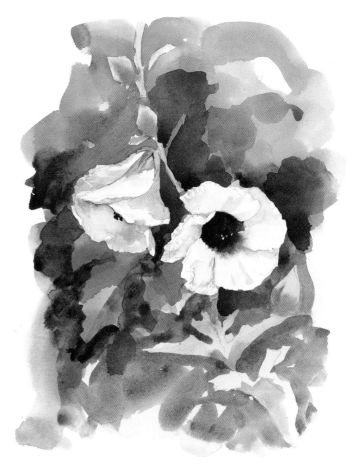

The outline of the pale yellow flowers was described by a Sap Green background wash. A darker wash of Viridian was then painted up to and around the perimeter of the lightest leaves. A further wash of Indigo was painted around the darker leaf shape in the middle. Thus the leaves were created by being left out of successive washes.

together. They may come from an individual stem or fan out from behind a flower.

Lift leaves out of a background wash by darkening the foliage around them. Then paint the detail into the leaf. Look for the main lights and darks; the veins could be described by the shapes made between them or painted as lines.

Dynamics

Look for dynamic directional lines, stems that thrust upward diagonally, or leaves that radiate from a central point. Above all put the painting first, before faithful representation of the chosen scene. You are a painter not a photographer, so use the freedom and licence that gives you.

Small Copper on Thistle
54 x 34 cm
(21 x 13 in)
Marion Harbinson
Adroit use of masking on stems and spikes has enabled the artist to wash colour freely over and around the angular shapes of the thistle. The result is a dynamic contrast of hard- and soft-edged washes conjuring perfectly the prickly character of the thistle.

project

Colours: A full selection

Paper: Sketchbook

Size: Maximum 28 x 38 cm
(11 x 15 in)

Location: A field full of
flowers

*Compare the sizes of the
near and middle-distance
flowers, and paint a quick
sketch to record this. I
washed the flower colour
all over first and then
lifted out the light parts of
the flowers with a tissue.
Next I painted a Sap
Green, Viridian and
Prussian Blue wash around
the different-sized flower
heads. Even in this simple
sketch a sense of depth
begins to emerge.*

Creating Depth and Distance

The aim of this project is to create a sense of distance by
scale, in this case the relative size of the flowers. To achieve
this paint large flowers in the foreground and gradually
smaller and smaller ones behind.

You will find it easier to sit on a low stool or even on the
ground if the flowers are not too tall. Sit close to, or among
the blooms, so that those near you loom large. Hold your
pencil vertically or horizontally out in front of you with a
straight arm and measure the length or width of the flower
heads against the length of the pencil. Mark the size with
your finger grip. Now look through the foreground flowers
to the middle distance and, still holding the pencil out
straight in front of you, compare the sizes of the middle
distance blooms with the flower heads close to you. You will
immediately see how much smaller they are.

Repeat the exercise with the flowers in the distance, and
you will probably find them too small to measure.

Now translate this information into a painting of the field
of flowers. Start with a quick sketch to practise the relative
proportions, and then proceed to a finished painting.

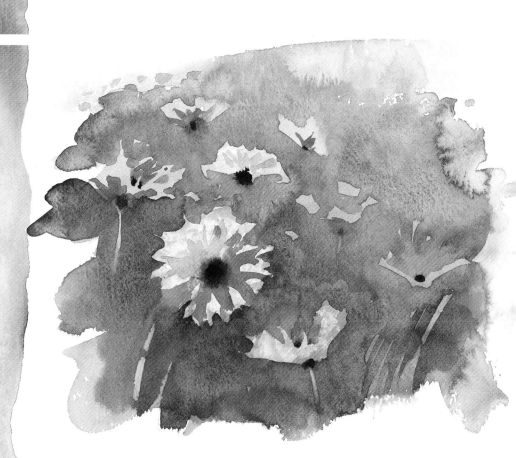

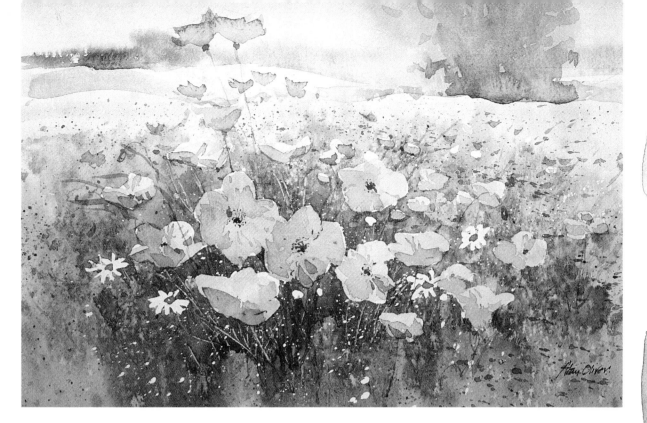

Poppy Field
28 x 38 cm (11 x 15 in)
Alan Oliver
The artist has drawn large poppy heads in the foreground, some full on to the viewer, some turned upward. Smaller poppy shapes are dispersed among the large blooms and above *them on the right, immediately giving the impression of being further away. A haze of pink suggests the distant flowers with some well-placed spatter to imply individual blooms. The darker foliage around the foreground blooms and the light distant hills enhance the sense of distance already created.*

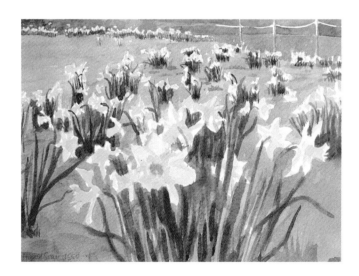

Springing Up
18 x 25 cm (7 x 10 in)
I drew the relative sizes of the daffodils and their leaves, one behind the other. I laid a wash of Sap Green, reserving white paper for the flowers. The diminishing scale of the flowers created space from foreground to background.

self-assessment

❀ Is the relative scale of the flowers successful?

❀ Has a sense of depth been created?

❀ Have you played light against dark, dark against light, to bring out the flowers?

❀ Did you vary the amount of detail from foreground to background?

flower studies

There will be times when you want to **paint flowers** as individual subjects and to **investigate** them with the brush without having to think of **compositions** and **backgrounds**. These painted studies are a **sheer delight** both to do and to view. You can paint **every detail** of the flowers with **loving attention** without worrying if you are overworking the painting.

Although it can be painstaking and time consuming, **the joy** of **close observation** and being able to put down exactly what is in front of you is often less taxing than trying to paint all the elements of a **broader** view. It will enable you to learn to **draw** and to **look at** negative spaces **without other concerns** filling your mind.

Examining each **petal** and **leaf** and the centres of the flowers gives you a greater **understanding** of their **composition** and will help you to simplify them convincingly **in later paintings**.

chapter thirteen

A DEGREE OF FINISH

A **flower study** does not have to be equally finished all over. Some half-finished **leaves** or **blossoms** make an **excellent counterfoil** to fine detail. Nor is it necessary always to paint in **great detail**. These studies are not **botanical paintings**. They are an opportunity to **observe**, and become familiar with, a fascinating subject.

Blue and Purple Irises
76 x 52 cm (30 x 20½ in)
Elizabeth Blackadder

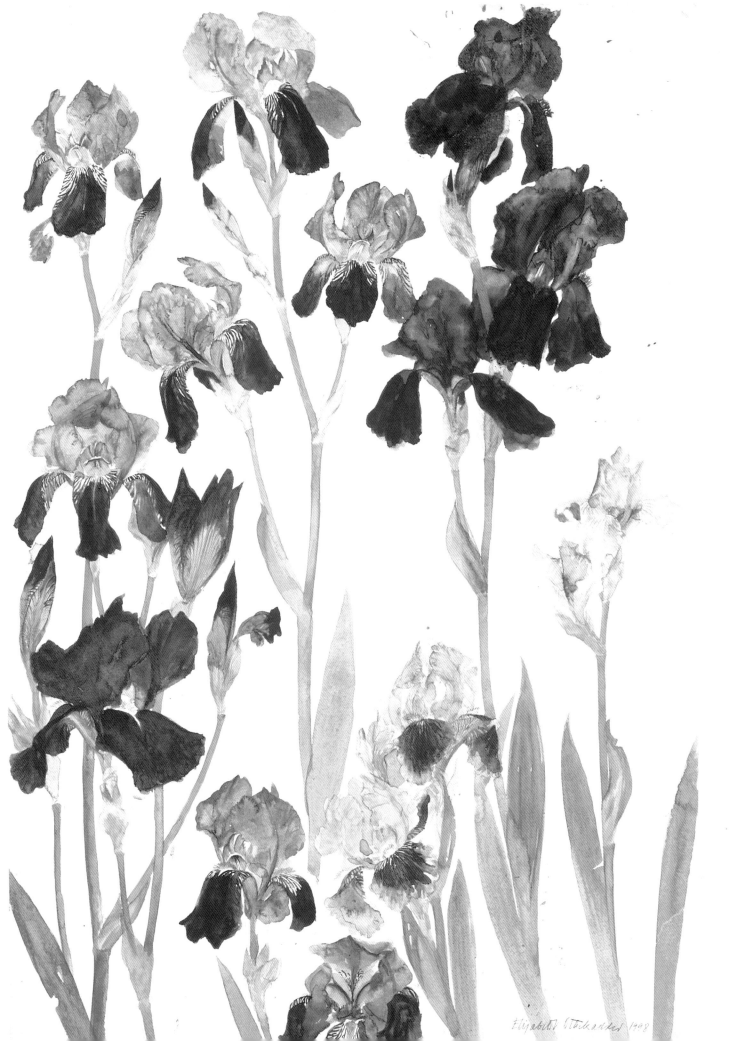

Elizabeth Blackadder 1988

Background and support

It is best to work under an even light and avoid strong shadows. The background of your painting is most likely to be the untouched white paper, so it will help to position the flowers against an actual white background. Then, as you observe, a similar set of relative tones will be in place. If you are working upright you could tape or Blu-tack a single stem to the drawing board. Standing the stem in a vial of water will greatly prolong its life. Use oasis to hold a stem in place on the table, or Blu-tack or tape the stem inside the rim of a jar.

Laying the flower down on a white ground also looks good, but will bend and flatten some of the leaves. To avoid confusion include the cast shadow.

If you are painting the flower *in situ* an uncluttered background definitely helps.

The smoother the paper you use the crisper the finish you will achieve. As you are painting fairly dry you can use HP paper without having to stretch it. You could also work on tinted paper.

Drawing and observation

You can paint straight onto the paper without a preliminary drawing, but I do not advise this to start with. Draw a careful outline sketch with an HB pencil as a guide for your brush. Include each petal, the stamens, the specific outline of the leaves, and even the veins. Time spent on this

This delicate study of a flame lily was painted with fairly dry paint on a textured paper. The sprig was painted while on the plant and chosen for the arrangement of the leaves and flower head, which made an interesting design.

will save you mistakes later and enable you to work on all areas of the same colour at the same time. It will give you confidence to paint because the hard work is done.

Draw lines with a light pressure, but dark enough to see. Before you begin to paint, step back to view, or hold the drawing up to a mirror to find any glaring mistakes. Look again at shapes and structures in Chapter 4 to help you draw accurately.

Comparisons

Compare the positions of leaves and petals with each other. Does this one lie vertically below that one? Is that leaf horizontally in line with those stamens? Run imaginary lines across your page up and down to juggle the pieces into their rightful places. Use the place you started from as your reference point and refer all the elements back to that.

Starting light

When you are satisfied with your drawing start with a light, dilute wash, leaving white paper for the lightest parts. Gradually strengthen the washes as you build up detail. To bring the petals alive paint dark up against light and vice versa. A thin petal-coloured outline will help differentiate one petal from another or separate a petal from the background.

Building up

Paint the dark centres and darks between stamens boldly. The greater the contrast of tone the more three-dimensional the flower will look, and hence more real. Use a fine brush and fairly dry paint to put in the darker petal colours. Stroke the colour out towards the light areas with the tip of the damp brush.

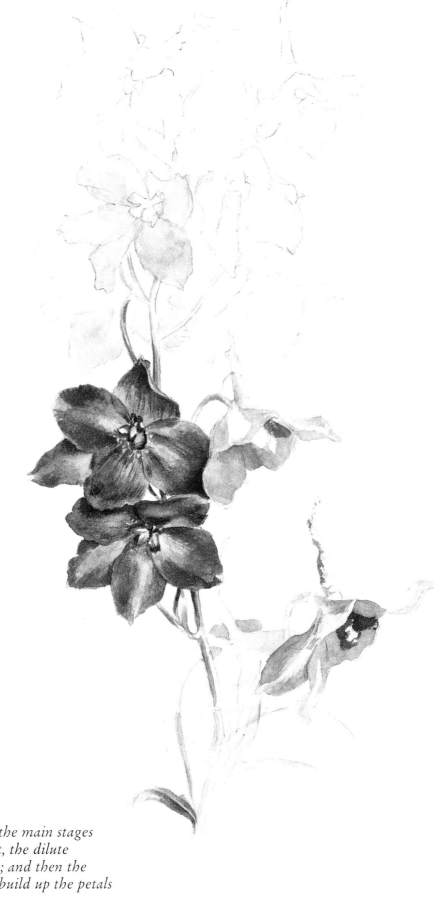

This illustration of a delphinium shows the main stages of development. First, the drawing; next, the dilute washes over the petals, leaves and stems; and then the small washes and fairly dry colour that build up the petals flower by flower.

Overlapping petals

Establish one petal behind the
other with contrast of tone.
Where you have repetition of
overlapping petals, such as a
rose, paint strong pigment
into the bases of each petal
and drag this colour out
into the lighter areas with
a slightly damp brush. If
your brush or pigment is
too wet you will lose
control. Dab excess
moisture off your brush
and palette and carry on.

Do not be afraid to
exaggerate the lights and
darks to help create the
form. If you have
overdone the effect
you can always
modify it later.

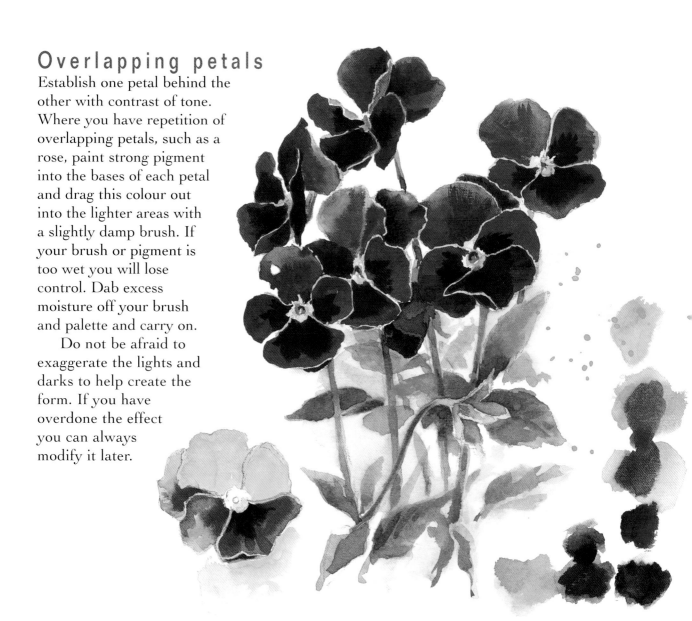

Variegated petals

Petals are often more than one
colour. Note first whether the
lightest colour is harmonious or
complementary (opposite) to the
other colours. If they are
harmonious the lighter colour
can be painted under the darker
colour adding to the radiance of
the subsequent layers. If the
colours are opposite the
undercolour will cause the other
colour to go dull.

practical tip

❀ Flowers move, so aim to
paint your first study at one
session. Choose a subject and
size you can complete in the
time you have available.

*In this study of
pansies a strong
yellow was painted
over all the flower
heads and then the
deep rich red-
browns were
painted over the
top. The yellow
remains as the rim
of the pansy and
glows through the
subsequent washes.
The 'blacks' were
mixed with Mauve
and Sepia.*

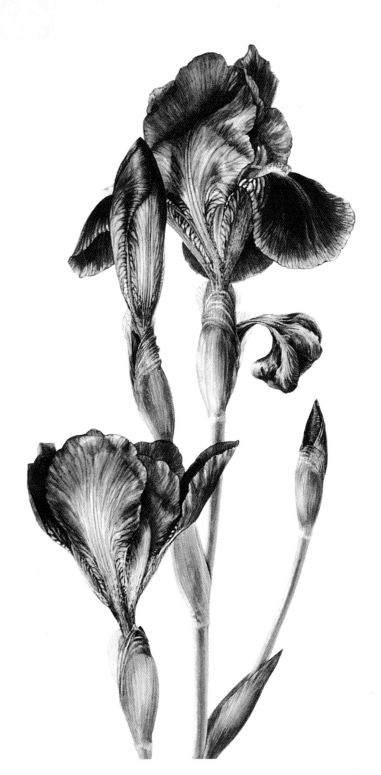

Shading

As the petals twist away or curl in on themselves the darkest parts can be painted in the petal colour mixed with a little of its complementary to darken it down. Thus you would add a touch of green to pinks and reds, and a little violet to a yellow.

To make the stem and buds appear rounded darken one side more than the other. To demarcate the light side from the white paper background a thin outline can be used. If it appears too hard edged, drag the colour gently into the stem with a damp brush.

The greater the variation of tone across the stem or bud the more round it will look.

Details

As the details get finer use a smaller brush. Give even the anthers on the end of the stamens a dark side and a light side to suggest their roundness. If they are yellow, darken their underside with a curve of Yellow Ochre or Raw Sienna. If orange, try Burnt Sienna.

Paint the finest details, such as the veins on the petals, with a size 00 sable brush. Do not let them dominate; they will be darker where the petal is in shadow and virtually disappear where the petal catches the light.

If you want to mask out tiny details at the beginning, use a pen and fine nib to paint on the masking fluid rather than a brush.

Iris Germanica
60 x 42 cm (24 x 16½ in)
Coral Guest
Do not be afraid of using strong darks. The dark purples and contrasting lights are the key to both the shiny and velvety texture so beautifully demonstrated on the petals of the iris in this painting.

Leaves

Give to the leaves the same attention that you lavish on the flowers. They are a wonderful counterbalance. If the flower is light in colour use the leaf behind it to make it stand out on the white paper.

It is easy to get carried away with the different tones playing across a leaf, so half close your eyes to see the light and dark sides of the leaf. Wash this in first before concentrating on the specific details.

Leaves are often tinged with reds and yellows. Blend the colours with wet-in-wet washes.

Catching the Light

To lighten areas that are catching the light you can lift colour from the leaf with a damp brush or sponge after the paint has dried. Often it is better to ignore details on the leaves in favour of a darker wash to emphasize the twist and turn of the leaf. Seek out the curls and folds of individual leaves to create variety, and angle them to enhance your design.

Painting veins

There are many ways to describe the veins coursing the leaves. You can reserve them between washes by painting the spaces between them. Or you can mask them out beforehand and touch them in later simply by stroking the colour across from the surrounding wash with a damp brush. Alternatively you could lift out the veins with the tip of a damp brush, or you

exercise

❀ Choose a flower with lots of leaves, put away your ready-mixed greens and mix your greens from a variety of blues and yellows.

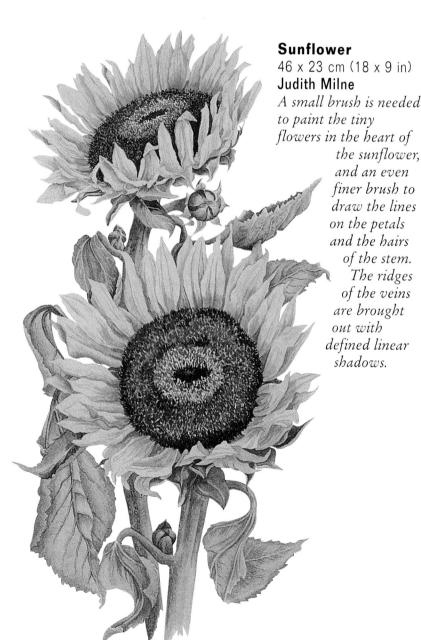

Sunflower
46 x 23 cm (18 x 9 in)
Judith Milne
A small brush is needed to paint the tiny flowers in the heart of the sunflower, and an even finer brush to draw the lines on the petals and the hairs of the stem. The ridges of the veins are brought out with defined linear shadows.

could use Lemon Yellow or opaque white to draw in the veins over the top of the dried wash.

Veins that stand proud of the leaf can be emphasized with a dark narrow line along one side. Take care to be consistent with your lit and shaded side.

Finishing Off

One of the enjoyable aspects about making flower studies is that you can actually 'overwork' your study with impunity. As it is the flower itself that you are studying you can sacrifice the medium to the subject. You can keep building up or lifting off colour until you are satisfied. Here is one occasion when you are encouraged to fiddle!

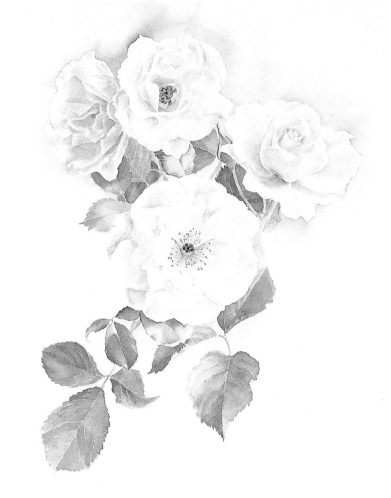

▲ Virgin Bride
35 x 28 cm (14 x 11 in)
Where the leaves fall behind the roses they are used to describe the edges of the white petals. The leaves are painted first with a pale wash of Sap Green for the colour of the veins. Then the darker green is laid on top in the sections between the veins. Sometimes the veins are ignored in favour of a darker wash to show the twist of the leaf.

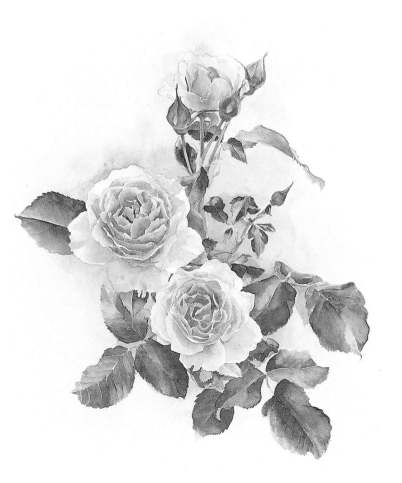

A Rose By Any Other Name
35 x 28 cm (14 x 11 in)
The splendour of these roses is accurately observed and yet the paint has been allowed a measure of freedom within the small washes that make up the petals and leaves, thus preventing a static image and giving life and movement to the study.

demonstration
Studying a Flower

HAZEL SOAN

The three stages of a flower encapsulated on this one stem – the closed bud, the opening petals, and the fully opened bloom – gave me the perfect opportunity to study the stylish Stargazer Lily in all its glory. I painted under an even light and placed a white background behind the vase in which it stood.

colours

Alizarin Crimson	Ultramarine Blue
Lemon Yellow	Yellow Ochre

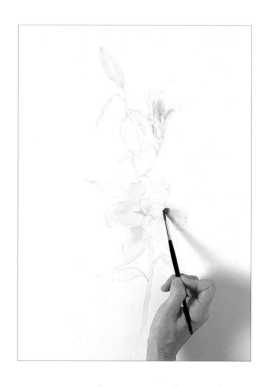

▶ **1** I chose HP Daler Board and a 2B pencil. First I made a light sketch to find the positions of the flowers relative to each other, then I drew carefully every curve and every shape outlining the flowers, leaves and stamens, always aware of the overall shape of the bloom. I checked all the petals radiated from the centre of the open flower. I laid a pale Lemon Yellow wash over any area of green or yellow with a size 4 sable brush and painted a pale wash of Alizarin over the coloured areas of the flowers.

◀ **2** I painted round the stamens, leaving them as white paper on the lower bloom. In the opening bud I painted them with Lemon Yellow and Alizarin, making a rich orange. I re-damped the interior portion of the petals and touched neat Alizarin into this area, allowing it to spread up and into the rest of the petal, creating depth within the flower.

▶ **3** I painted the leaves with pale Yellow Ochre, Lemon Yellow and Ultramarine Blue, equivalent to the colour of the veins. Sometimes I mixed the colours in the palette, and at other times I let them run into each other on the leaf so that the tips of the leaves became darker. I re-wetted the narrower petals of the open flower and into the area where the top petals overlap I placed strong Alizarin, pulling the colour up and away from the centre of the flower towards the tip, letting it flood gently into the damp petal but leaving the edges of the petal pale.

◀ **4** To make the lighter petals stand out clearly I damped the leaf area closest to the petal edge and plunged a dark mix of Ultramarine, Yellow Ochre and a touch of Alizarin into the corner.

▶ **5** I built up the velvety texture of the Stargazer petals with dry-brush strokes dragged from the centre of the flower out to the tip, keeping the hairs of the brush splayed as I followed the curve of the petal. I strengthened the darker tones of the bud, leaves and stem so that the flower looked three-dimensional. Where the edge of a petal looked lost against the white page I introduced a line or a shadow of pale warm grey made with Ultramarine, Yellow Ochre and Alizarin. Where the light caught the top of a leaf I lifted out some colour. To avoid hard edges on the patina of spots I damped the petals very slightly before touching in the dots.

Stargazer
53 x 35 cm (21 x 14 in)

exotics

The **alluring colours** and exaggerated **size** of **tropical flowers** are an **inspiration** in themselves. I spend a lot of time in southern Africa where **exuberant** flowers grow not only **in gardens** but **wild** by the roadside. I am constantly **amazed** at the **profusion** of oleander bushes along the central reservations, the hibiscus trees that look like children's paintings, and the **splendid** ranks of **hazy blue** when the agapanthus are in **full bloom**.

Thanks to **hothouses** many **exotic flowers** are also available in cooler climes. The **orchid** and **passionflower** are both fascinating to paint and the **amaryllis** has become a popular house plant.

chapter fourteen

EXPRESSION

The approach to **painting exotic flowers** is no different from that for other kinds of flowers, but you feel you have the excuse to use **lashings of colour** and **bolder** brush strokes in an attempt to mimic their **splendour**.

Strong colours and large forms may **excite** you to experiment with less representative pictures. Freeing up your **brush strokes** and allowing the watercolour to flow will show you what **beautiful effects** it can create 'on its own'. Working with a **large brush** and **a lot of paint**, flowers can be loosely described in an impressionist manner.

Facing the Sun (detail)
35 x 35 cm (14 x 14 in)

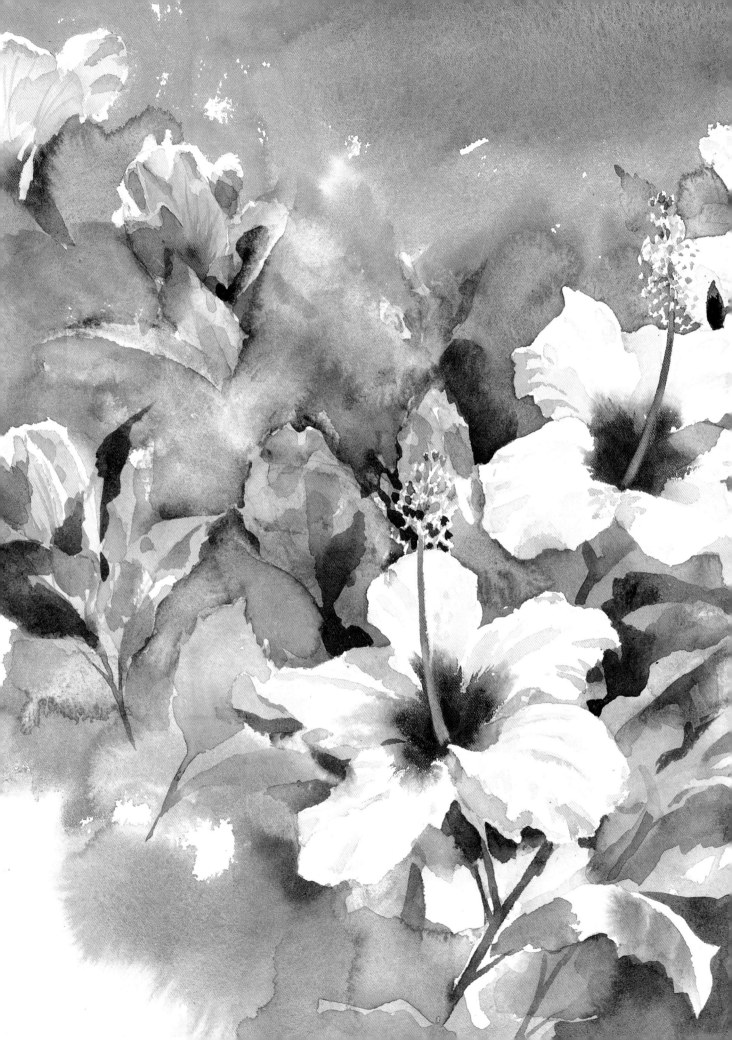

Vivid colours

Some of the colours of tropical blooms are so vivid that they are hard to believe. The strong sunlight and deep blue skies certainly enhance their glory. Mix plenty of pigment into rich creamy solutions, otherwise you will find that the colours dry too light.

I find I veer away from mixing complementaries with my colours, as there seldom seem to be greys; the darkest parts and shaded areas of these flowers are full of colour. Where shadows are cast across petals a dilute blue or violet wash may look more effective than grey.

A Cadmium Yellow wash was painted over this Canna flower. Intense red was then dabbed or brushed in to re-wetted petals. The undersides of the petals glowed with strong reflected sunlight, so to retain colour I darkened them with Crimson Alizarin and Yellow Ochre, cooler versions of red and yellow.

Larger than life!

Not only do the colour and size of tropical flowers appear exaggerated, but also the stamens and pistils; and even the stems are often bigger and fatter. Sometimes you have to do a rethink on what constitutes proportion. Careful observation is essential.

Glossy leaves

The leaves of exotic plants are often larger and less delicate than their northern counterparts. Paint them boldly with attention to their three-dimensional form. Waxy or succulent leaves really shine in the sun. Make the darks truly dark and leave the lights as white paper to suggest their glossy nature.

The shadows and darks under the leaves are often very dark. Avoid black as it looks rather dead; instead mix dark tones with Indigo and Sepia, Ultramarine

Bird of Paradise
30 x 23 cm (12 x 9 in)
The colours of the flower were flooded on an underwash of orange. When dry, a variegated background wash of purple, green, sepia and blue described the vivid angular shapes.

Amaryllis
53 x 25 cm
(21 x 10 in)
Three-dimensional form is suggested by lifting out colour on the lit side of the leaves and stem, and highlights are painted on the shiny petals with white gouache. The matt texture of the bold black background is created with charcoal and dramatically brings out the exotic red.

and Burnt Umber, Viridian or Indigo with Crimson Alizarin. Tubes rather than pans will help you to make strong colours.

The proliferation of insects in tropical countries ensures a good number of imperfect leaves. Rather than ignore these, use the patterns and textures of the diseased and perforated foliage to your advantage. Create mottling with sponged pigment, dribbles of clean water or drops of waterproof ink (see Chapter 3).

Freedom and expression

Exotic flowers are an excellent way of breaking old painting habits. Just getting involved with their bright colours and their unpredictable shapes makes you open your eyes afresh. Before you know it you are off once more on a wonderful road of discovery.

Edge of the Amazon
55 x 75 cm
(22 x 30 in)
Myriad greens describe the leaves in this picture of tropical abundance. Cool blue-greens are plunged wet-in-wet into warm yellow-greens, making exciting contrasts. The more intense the darks the glossier the leaves look. Amidst them the water creates an area of calm.

Index